Drawing and Painting
Sports Figures

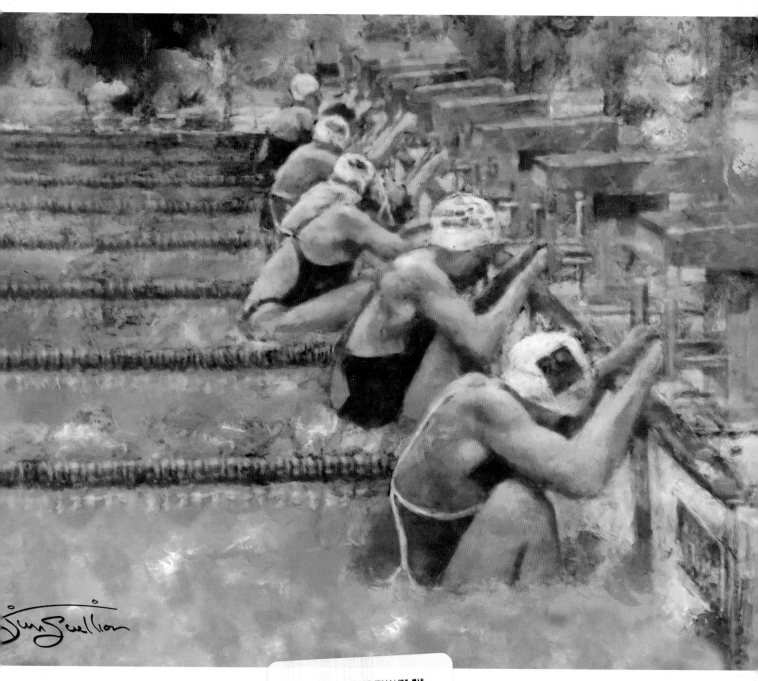

Dedication

This book is dedicated to my two sons, Christopher and Kevin, both great artists in their own right, and also to my beautiful wife, Margherita, my most honest critic, my greatest supporter and my best friend.

Drawing and Painting
Sports Figures

JIM SCULLION

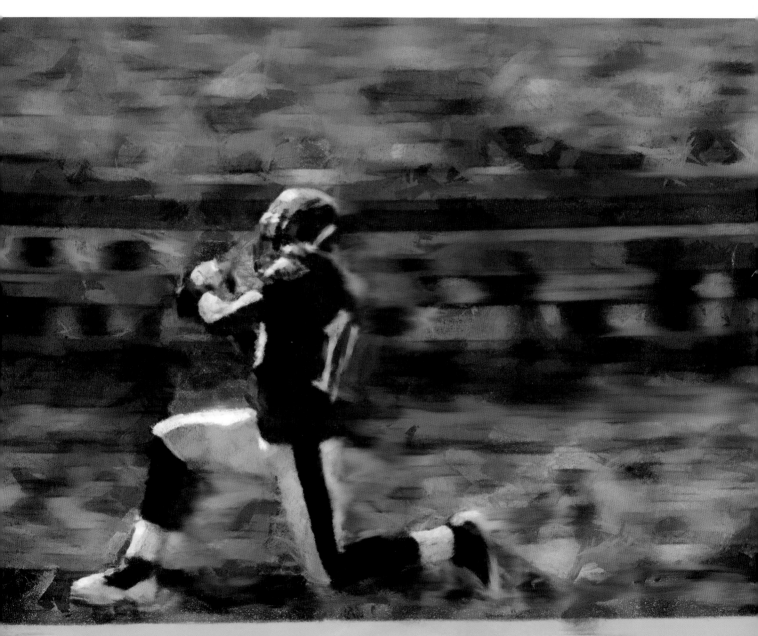

Search Press

First published in Great Britain 2012

Search Press Limited
Wellwood, North Farm Road,
Tunbridge Wells, Kent TN2 3DR

Illustrations and text copyright
© Jim Scullion 2012

Photographs by Paul Bricknell at
Search Press Studios

Photographs and design copyright
© Search Press Ltd. 2012

ISBN: 978-1-84448-773-8

The Publishers and author can accept
no responsibility for any consequences
arising from the information, advice or
instructions given in this publication.

Suppliers
If you have difficulty in obtaining any of
the materials and equipment mentioned
in this book, then please visit the Search
Press website for details of suppliers:
www.searchpress.com

Printed in Malaysia

Acknowledgements

Many people were involved directly and indirectly with the
creation of this book. I would like to thank all the staff at Search
Press for making me really feel part of the team. A special thank
you to Roz Dace for having faith in me to do this book and to the
editor, Sophie Kersey for her support, guidance and amazing
ability to create something from my sketches and scribblings,
also to Paul Bricknell for his expert photography. Thanks to
Margherita for the constant interruptions, with coffee, scones
and the occasional cuddle. Thanks to Tony Higgins of FIFPro
for his kind words in the Foreword. A special thanks to all the
budding artists who have attended my workshops over the years
with a special mention to the young people of PETAL, especially
Laura Anne, Laura Jane, Jade and Kiera. Also my co-worker in
those sessions, Helga, who will be sadly missed by all.

A big thank you to everyone involved in sport at all levels:
athletes, trainers, coaches, commentators, cameramen, pundits
and photographers, who all add to the spectacle that is sport.

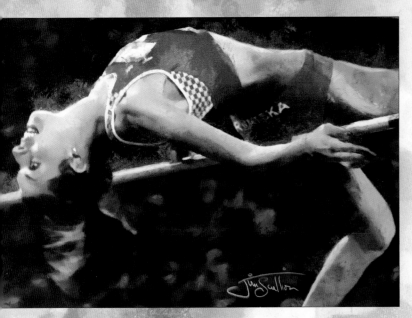

Page 1

Ready for Blast Off

*Preparing for a back stroke start, which is one of the most
important parts of the race. A good powerful start can make the
difference between winning and losing. Painted in acrylic, pastel
and coloured pencil on Not watercolour paper.*

Pages 2–3

Touchdown

*What this painting lacks in detail is more than compensated for
by the feeling of movement created by the loose brushwork and
the colour. Painted in acrylic and watercolour on Hot-Pressed
watercolour paper.*

Left

High Jump

*Capturing the Fosbury Flop method in the high jump. Painted in
acrylic and pastel on Hot-Pressed watercolour paper.*

Contents

Foreword
by Tony Higgins

I first met Jim Scullion at an event in Glasgow in 1991 at an exhibition of his work. Jim had invited me along because as head of the soccer Players' Union in Scotland at that time I had a reputation for mobilising players to combat racism which blighted our game then.

Jim had painted some wonderful pictures of players at that time, including Paul Elliot and Mark Walter, both of whom were victims of racial abuse.

Jim was developing a real reputation as one of the foremost sports artists of his generation. He won awards at European level, and his ability to capture the athlete in full competitive pose marked him out from most other sports artists.

As you go through the book, you will see how he developed the technique that makes him the artist he is. He also has a great ability to create an atmosphere when he is painting a figure from sport. You almost feel he was sitting in the stand with his easel, painting the action live.

Jim has always been an artist with a social conscience. In my job now with FIFPro (soccer's World Players' Union), one of my responsibilities is to head the Player Social Responsibility section. FIFPro works with four charities: Show Racism the Red Card, Perres Peace Foundation, Balls to Poverty and Coaching for Hope. All have a focus on children, using the role model status of professional footballers to present a social message. We work all over the world but have focused on Africa following the soccer World Cup in 2010 with Balls to Poverty and Coaching for Hope projects.

Jim does his own charity work using art as his focus, but always supports my work when he can. The book again illustrates his ability to capture the joy and hope of young people through painting.

Despite his undoubted talents as an artist and his awards at European and world level, he is one of the most humble and sincere men I have ever met. This book encapsulates what Jim Scullion is all about; a supreme artist, yet, one who wants to share his talent with other people in an effort to get them to fully exploit their own artistic potential, be it for fun or otherwise.

I have the great honour of being painted by Jim. A 'Scullion' hangs proudly in my office. Hopefully by the end of this book you will also feel that Jim has brought some joy and understanding of painting into your life.

Opposite

A painting depicting some images from the work carried out by FIFPro – watercolour and acrylic ink on watercolour Not paper.

Tony Higgins was previously chairman of the Scottish Professional Footballers' Association. He left that position in 2006 to become the Scottish representative of FIFPro, the international soccer players' union.

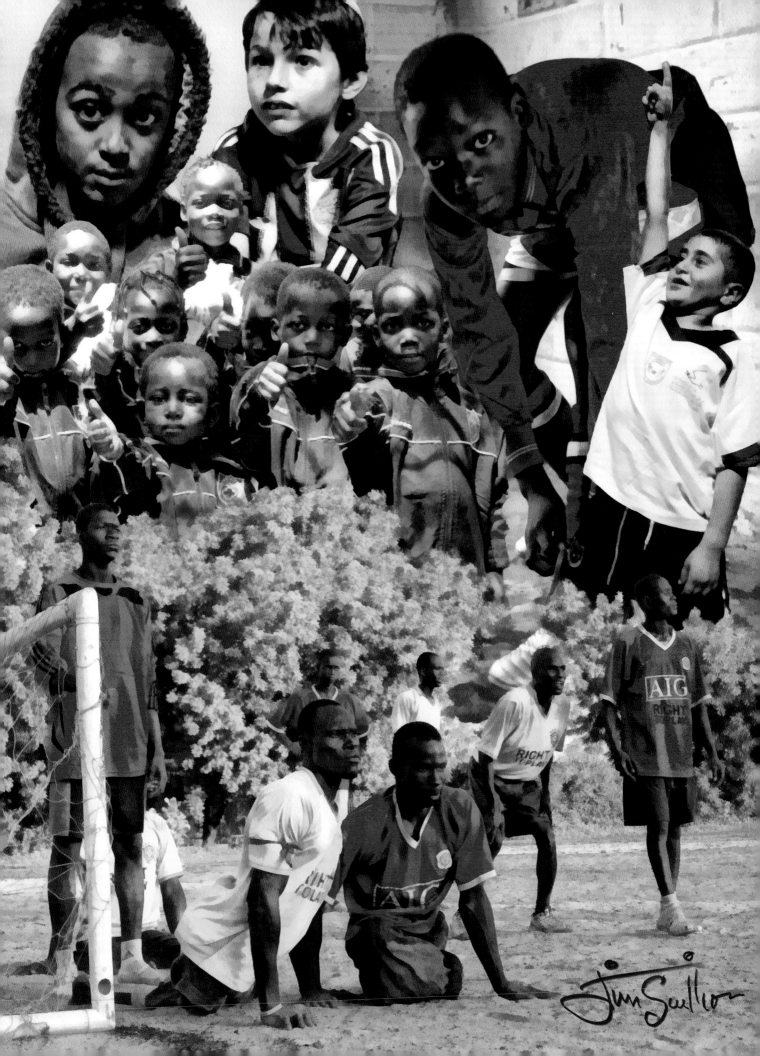

Introduction

At the age of 12, I received a school report from the Head of Art which stated: 'Probably the most naturally talented artist I have ever met, but will get nowhere painting footballers'. This signalled the end of my formal art education, but I was determined to continue painting and trying to learn. From the day that report was written to the present (over forty-five years), despite not having a single art lesson, I have consumed countless art and art instruction books, lives and works of the artists, television programmes and DVDs. I never tire of trawling around galleries, studying the artwork from close quarters. I find it almost as illuminating to visit amateur art displays or school and youth art shows, which often display work full of energy and experimentation. I feel it is important to experiment with different materials and styles, as this helps to keep my artwork fresh and new.

This book is not simply about painting soccer players, but about capturing the essence of sport: passion, glory, hard work, training, determination, artistry, movement, victory, joy, pain, and the agony of losing. These can also relate to everyday life and to people in general. Anyone who has an interest in painting the human form should strive to inject these facets into their work.

Sport has been captured by artists for centuries. There are many examples of early Roman and Greek paintings, statues and carvings depicting athletes, discus throwers, archers and chariot racing.

My own fascination for portraying sport started as a young boy. I listened to soccer on the radio and tried to draw how I perceived the goals to have looked. I lived overlooking a second division soccer stadium and spent much of my time in and around the grounds. I was fascinated by the crowds of singing and cheering fans. At the age of five I was taken to a Celtic match and my lifelong love affair with Celtic Football Club was born. Having been an artist for Celtic for almost thirty years, I am still totally enthralled by the game, and strive to capture the colour and the passion.

Over the years I have worked with many other soccer teams and many other sports both at home and abroad. I feel very privileged to have portrayed athletes: men and women who work hard to strive for success, by extensive preparation and training, to display their best efforts under the scrutiny of the public eye. With this book I hope to convey my love for both art and sport and share some of my working methods.

A Tribute to the Master
Pen and ink.

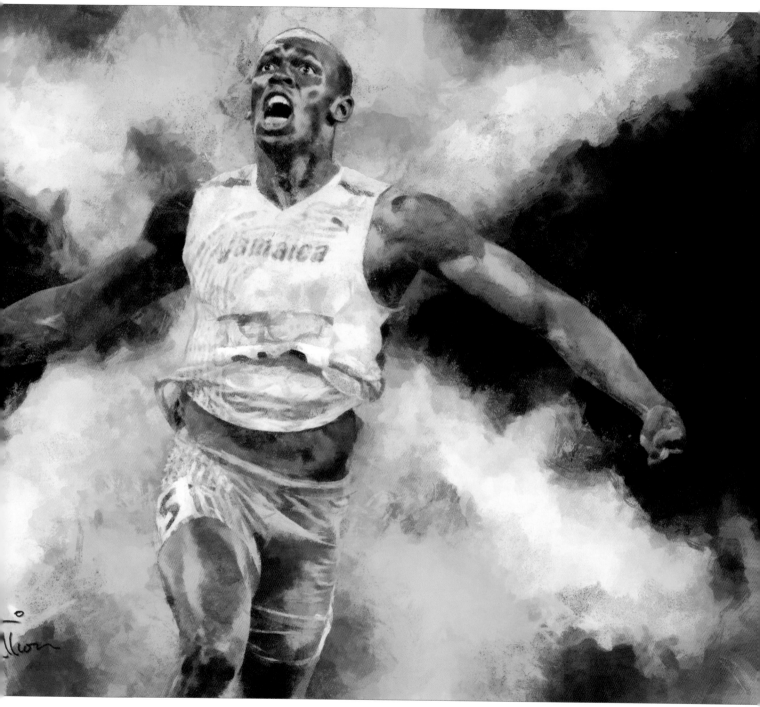

Usain

This painting attempts to capture the power, strength and exhilaration of this great athlete, Usain Bolt, as he crosses the finish line. It is painted in acrylic, watercolour and coloured pencil on Hot-Pressed watercolour paper.

Materials

The wide array of drawing and painting materials and supports currently available can be confusing for artists and budding artists when trying to choose the right tools for the job. I can help a little by giving you an insight into the materials that I use and how I use them.

Drawing materials

There are numerous pencils and drawing sticks available. The graphite pencil is probably one of the most used tools in the artist's toolbox and one of the most versatile. It comes in various grades of softness or hardness of the graphite lead, ranging from 9H (the hardest) to 9B (the softest). The harder the lead, the lighter the tone and the softer the lead the darker the tone. An HB pencil lies in the middle of the scale and makes an ideal all-round sketching pencil. I use HB pencils when sketching and doing preparatory work. I also use these pencils in my workshops with young people. They are encased in natural wood and are easy to sharpen with a sharpener and a knife and are very hard-wearing. The leads do not break easily and they give a great range of tones depending on pressure applied when drawing.

For serious drawing, such as a pencil portrait, I will use a 3B pencil to give me darker tones for blending. My preferred option in this instance is to use a mechanical pencil containing 0.5mm leads, which removes the need for sharpening, or an art pencil with a thicker lead. The very fine leads used in the mechanical pencil are very brittle and can break easily with too much pressure, so these can take quite a while to get used to.

You can also buy a very versatile water-soluble sketching pencil which can give great results. Charcoal is also an ideal sketching tool, although I prefer to use the charcoal pencils as I tend to get things too messy when using charcoal sticks.

Coloured pencils are a particular favourite of mine. I also use watercolour pencils, which are worth exploring. I tend to mix the brands of pencil when I am working. I very seldom buy whole boxed sets of coloured pencils and tend to buy single pencils in the colours I need.

When using dry media, blending tools are necessary, I use tortillons (also known as torchons) which are constructed from tightly wound paper made into the shape of a pencil. These are fairly inexpensive to buy although occasionally I make my own.

You will require erasers and I use four types: kneadable putty erasers, soft, hard plastic and a small battery-operated eraser. Remember that erasers are not only for removing mistakes but should be used to help create tone and dimension in your work. Occasionally I will use a piece of bread and squash it continually until it becomes like putty and then use it to gently remove layers of dry media such as pastel, pencil or charcoal.

I frequently use pens in my drawings and prefer to use an art pen with a reservoir which can be filled with Indian, water soluble or acrylic ink.

Clockwise from bottom left: mechanical pencil leads, mechanical pencil, art pencil, tortillons, flat graphite pencil, graphite pencils, charcoal pencil, coloured pencil, white pencil, kneadable putty eraser, plastic eraser, craft knife, pen-style eraser and art pen.

Painting materials

Watercolours

There are many ranges and manufacturers of watercolour paint and it comes in two forms: transparent and opaque (solid colour). The latter is known as gouache. Transparent watercolour paint comes in two grades: student quality and artist quality but don't be tempted by the lower price of the student quality, as the colours are inferior and less light-fast which can lead to very disappointing results. I prefer to buy watercolours in a boxed set. They come in tubes, pans or bottles. I prefer the pans and the tubes as I find the bottled colours, although very bright initially, tend to fade more easily. Watercolour pan sets come in different sizes and include small, very portable outdoor sets. Pan sets also tend to have a palette built into the lid. Most manufacturers produce the same range of colours and if you choose the artist quality, you will not go far wrong. I use one set with two layers, which offers me a massive range of colours, and a small pocket set in a metal case with half pans, which is brilliant for sketching outdoors. I also use a set of gouache. All three sets allow me to remove the pans and replace them when required.

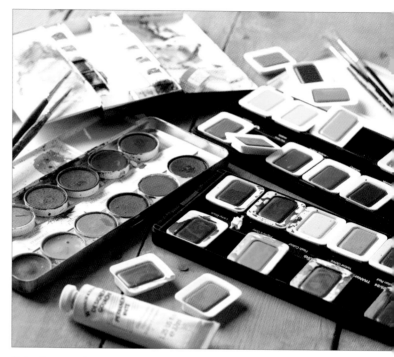

Sets of watercolour and gouache pans, and a pocket set of half-pans for sketching, plus white gouache in a tube.

Acrylic paints

Acrylic paint is one of the most versatile and fun media to use. It is water-based and requires only water to thin it. It can be applied to numerous supports including paper, canvas, board, wood, textiles, leather or glass. It can also be applied in numerous ways including brushes, airbrushes, knives or stamps. It dries very quickly and is permanent and light-fast.

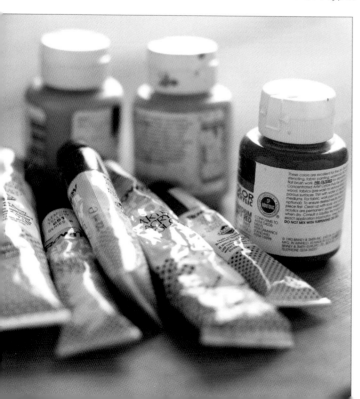

Acrylic paints in tubes and tubs.

There are numerous types of acrylic on sale including those made especially for craft use, model paints, acrylic sprays for car and motorcycle work and acrylic formulas for decorating work within the home. It is important to use acrylics designed specifically for artists. Acrylic paints for the artist come in several grades and are produced by different manufacturers. There is no guarantee that paints from different manufacturers are compatible with each other, but I have worked with different brands mixed together for over forty years without any problems. Unlike watercolours, the student quality acrylics are very light-fast and they mix well with the thicker artist quality paints.

Acrylics are ideal for sport art work and particularly for the way that I work. They are bright, colourful and so versatile. They are ideal for mixed media work as they work well alongside watercolours, pastels, coloured pencils and oils.

Acrylic inks

Without a doubt, acrylic inks are one of my favourite media. I first discovered them when I started exploring airbrushing in the 1970s, and was amazed by their versatility, strong colours and light-fastness. They are basically acrylic paints in liquid form. They have all the attributes of acrylic and can be applied using brushes, airbrushes and pens. Applied with brushes and further diluted with water, acrylic inks can create amazing washes that dry out permanently. They are ideal for creating detail in paintings and are perfect for technical illustration. I have successfully used several different brands. The ones shown here have a pipette in the lid so that you can make mixes using drops of each colour. I use this feature when making my own flesh colour mix, which is fifty drops of yellow, thirty of red, five of blue and twenty of black.

Pastels

Although it is a dry medium, using pastels is very like painting. They allow you to apply pure colour directly to your surface without the need for a brush. There are basically three types of pastel that I use: hard pastel, soft pastel and pastel pencils. Hard pastels are useful for drawing, preparatory sketches and producing detailed line work. Soft pastels are much richer in colour and are used to paint the colour in your artwork, as they are easy to blend and smooth. Pastel pencils allow detail to be added to your work. As soft pastels are blended and mixed on the surface of your paper, a large number of colours are required. Fortunately some companies do sell sets with colours specifically chosen for landscape work or portraiture. This can be a useful starting point for the newcomer to pastels.

Soft pastels, hard pastels and pastel pencils

Brushes

Recently I visited a large art store near my home and noticed an enormous display of brushes of every size and price imaginable. This made me realise how difficult it must be for people to choose the right brushes for their artwork. This is a very important choice to make. Over the years I have collected many brushes but I use only a favourite few, which have served me well and continue to do so. I have not bought a new brush in over twenty years. As I work mainly with watercolours, acrylics and acrylic inks, I have chosen brushes which suit my media and my style.

Acrylics and acrylic inks create the biggest problem with brushes. By their very nature, acrylics dry very quickly and if you leave a brush with paint on it for even just a few minutes, you can almost guarantee it will be totally ruined. No matter how careful you are, someone interrupting you, a phone call, someone at the door or a quick toilet break is all it takes to create what could be a costly problem. Always rinse your brush carefully when not in use.

Brushes are made from numerous materials: natural (including sable), synthetic, and a mixture of natural and synthetic. Many artists recommend that only synthetic brushes should be used with acrylics and suggest that sable brushes deteriorate with prolonged use of acrylics, but that has not been my experience. I hasten to add that I only use sable brushes with acrylic inks or heavily diluted acrylic paints –
I would not use them to apply heavy paint. I would recommend synthetic brushes or a synthetic/natural mix for use with acrylic paints. For diluted wash applications, use soft brushes and for heavier paint applications use firmer brushes.

For watercolour, if you can afford sable brushes then buy them, but that can be unbelievably costly. I use some sable brushes but find that many of the synthetic brushes are of a quality that compares very favourably with the synthetic and natural mix brushes.

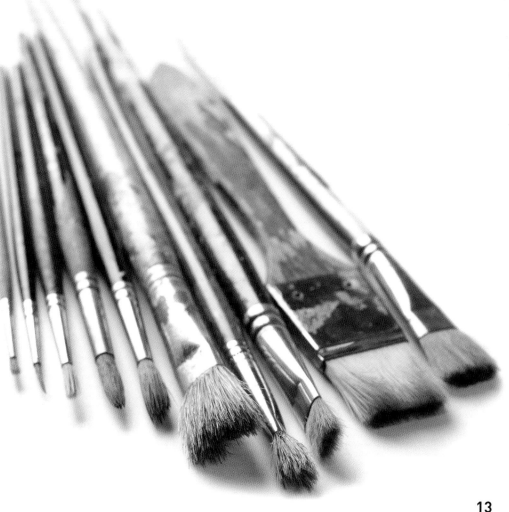

A collection of the brushes I use most often, including a no. 2 sable, a no. 1 sable, a no. 4 synthetic, no. 7 and no. 8 sable, a no. 16 flat bristle brush, a no. 8 bristle brush, a no 8 flat bristle brush, a 2.5cm (1in) flat synthetic and a 19mm (¾in) flat synthetic.

Supports

The vast array of drawing and painting materials currently on the market is matched by the large number of supports also available. The support I use depends on the work I am doing. I often use canvas with acrylics for commissioned work. I use a variety of paper for sketching and drawing but would use Bristol board – a heavy, smooth cardboard specially made for art – for fine detail pencil work. I use coloured matt boards as the support for detailed coloured pencil work.

I use a variety of watercolour paper for my acrylic ink and mixed media work. Watercolour paper comes in three varieties, Hot-Pressed (very smooth),

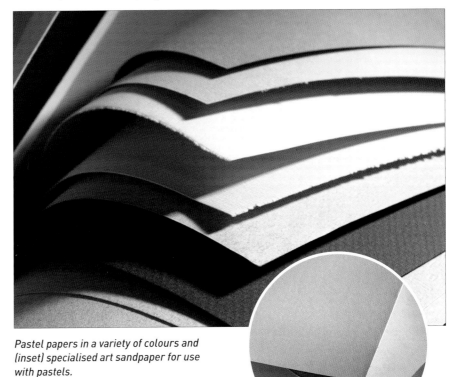

Cold-Pressed or Not (semi-smooth) and Rough. I use all three papers but prefer to use the Hot-Pressed, as its smooth surface does not instantly absorb washes and allows some great effects. It is also suitable for dry media and is therefore ideal for mixed media work such as the figurative and action-related paintings shown in this book.

I use a variety of pastel papers but prefer white surfaces as I feel the pastels glow more on such surfaces. I find specialised art sandpaper really good. This is a paper coated with a fine abrasive grit which holds the pastel well and allows you to build up more layers than regular pastel paper.

Pastel papers in a variety of colours and (inset) specialised art sandpaper for use with pastels.

Adapting supports

Occasionally I have to prepare my support to take the paint or pastel that I want to use. When using canvases, I prime them with several coats of white acrylic gesso. I will also do this with wood when using acrylics, and on paper when I want to use pastel and the surface is too smooth. Gesso stops the paint from soaking into the support and offers a fine textured surface to work on.

When using acrylics, it is also possible to use mediums and gels which have an impact on how the paint reacts with the support. Some give the paint a gloss or matt finish; some thin the paint while slowing down the drying time allowing more time to blend; some make the colours more fluid and easier to mix, some give the acrylics a metallic sheen, and others thicken the paint.

There are also a few pastes available which add a range of textures to the paint. I have used one to add a grainy texture to an acrylic ground, allowing me to add pastel to a painting, and I have also used a heavy paste to add a thick, textured dimension to paintings.

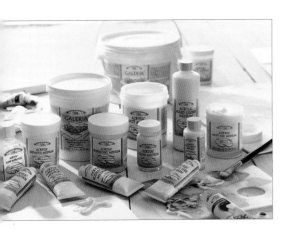

Mediums for use with acrylic paints.

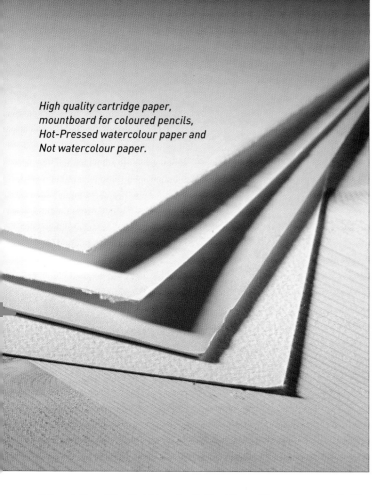

High quality cartridge paper, mountboard for coloured pencils, Hot-Pressed watercolour paper and Not watercolour paper.

This is one of two 7.62m (25ft) long murals at Celtic Park depicting the career of legendary football manager, Jock Stein. This was painted on 2.74 x 1.2m (9 x 4ft) sections of plywood, primed with white acrylic gesso. This sealed the wood from the elements and also created a fine textured surface for painting on.

This painting of South African footballer Steven Pienaar was painted in acrylic on board. The board was prepared using acrylic gesso and an acrylic paste was added during the painting process to add depth and dimension.

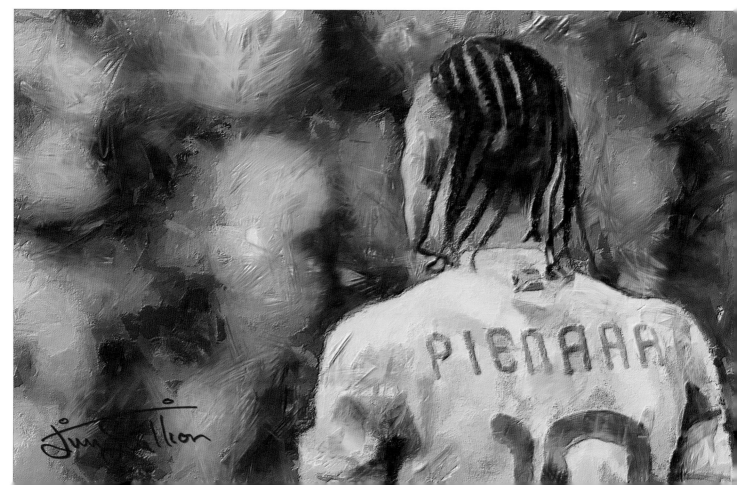

Other materials

There are several other tools that are necessary to help produce drawings, sketches and paintings. When starting out, a drawing pad or sketchpad is essential. If you want to seriously pursue an interest in drawing, a drawing board is vital. This does not have to be an elaborate or expensive piece of equipment. Basically all you need is a flat board. For many years I did all my artwork on the kitchen table. Most DIY stores will happily cut you a small piece of MDF or something similar, which is ideal.

Spray fixative.

A pencil sharpener is an obvious requirement although again there are choices. I am not a fan of electric sharpeners, or large desk sharpeners and tend to use a small hand-held sharpener or a craft knife. Use what you feel most comfortable with.

For larger areas needing blending I use kitchen paper, toilet paper or a piece of rag. There is a natural tendency to use your fingers to blend, but be sure that your hands are clean and dry as you can contaminate your artwork with a previously blended colour still on your hands.

Most manufacturers recommend that you apply fixatives to dry media to protect your work. Make sure that you use spray fixatives in well ventilated areas, and do not use around children or pets.

Wooden mannequins.

Water pots are essential for keeping your brushes clean when painting. I use two mugs for this as they are sturdy and inexpensive, or a jam jar.

A wooden mannequin is a useful addition to your toolbox if you are doing sport or any other figurative artwork.

I use a variety of knives and combs to apply and scrape off paint, including a steel comb used for removing headlice for creating texture, and sandpaper to sand off paint and add texture.

Adhesive putty is used to fix paper to a drawing board. I use a toothbrush for spattering paint and a palette for mixing paints and inks. Also useful for mixing is a transparent plastic cover that comes with CDs. This allows me to place paint or ink mixes on the artwork itself so that I can compare colours as I work.

Clockwise from bottom left: adhesive putty, set square, kitchen paper, water pot, drawing board, sketchbook, plastic CD cover, sandpaper, sharpener, china palette, craft knife and blades and toothbrush.

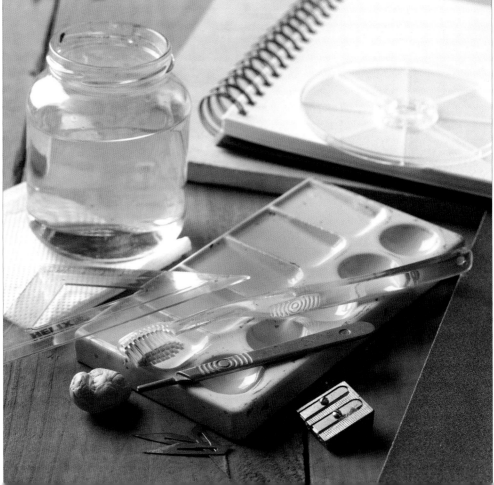

My studio

A studio is not essential in order to produce artwork, nor does having a studio guarantee you great artwork. For many years I drew and painted at the kitchen table without a drawing board. In fact all of the work for my first major solo exhibition was created in this setting. Working in this way taught me a very valuable lesson. When I finished painting for the day, I had to clean up my paints and brushes and restore the kitchen to its proper state for cooking. I learned to look after and care for my artwork and painting tools and devised ways of storing artwork and paints in a mixed state so I could return to where I left off in my next session. This is one of the main reasons for many of my brushes and paints lasting for over twenty years.

I now have the luxury of a studio in my own home which contains three main areas. The first corner contains a desk where I draw and paint using A0 and A1 sized drawing boards. I also have a large easel for larger work. In another corner I have a desk equipped with an array of computer equipment, including a high-powered computer attached to several external hard drives, an A3 scanner and an A3 printer. This computer is used for keeping my website up to date, checking emails and preparatory work for much of my painting. I also use the computer to create digital artwork and for this I use a graphics tablet and a variety of art and 3D programmes. I have several hundred data CDs and DVDs with photographs, scans, newspaper reports, and television interviews all relating to my artwork over the years. The studio space also contains a vast library of books, magazines and DVDs all relating to sport, art and travel. It also contains a couch were I can relax and do my research in comfort. The room is crammed full of items which are a constant source of inspiration.

A nearby room contains a dark room with an opaque projector and a large storage space for my art materials and paper.

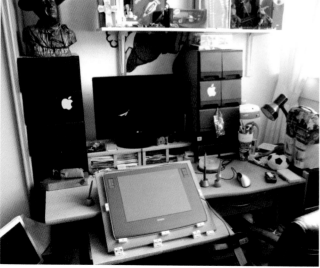

These photographs show two of the corner work areas in my studio.

Basic drawing techniques

Holding the pencil for writing (above) and for drawing (below).

Although drawing is a fairly natural and instinctive process, there are a few very basic techniques that will help in developing your skills.

The way you hold the pencil determines how you make marks on the paper. When drawing there are two main ways I hold the pencil. The natural instinct when given a pencil to draw with is to hold as you would when writing. When writing, we tend to hold the pencil very near the point and grip it fairly tightly. When drawing, hold the pencil two or three inches from the tip and relax the grip. Moving from the wrist allows the pencil to glide along the surface; this is ideal for drawing detail and short to medium strokes. The other way is to hold the pencil between the thumb and first finger only, with the pencil under your palm (see right), moving the forearm from the elbow, which allows you to make long broad sweeps. This is an ideal way to hold the pencil for using the side of the lead and creating broader strokes. These are the holds that I find most comfortable; experiment with these and find a way of holding the pencil that feels comfortable for you.

Drawing straight lines is something that is not particularly easy to do. If you need perfect straight lines, then do as I do and use a ruler. However, when perfect lines are not required, I find that drawing away from your body helps to create fairly uniform straight lines (see right).

When drawing with pencils, you are in control of how much tone and value is placed on the paper. This is determined by the amount of pressure you apply when drawing. The heavier the pressure, the darker the lines, the lighter the pressure, the lighter the lines. Using an HB pencil, draw a wavy line on a piece of paper, gradually adding more and more pressure as you go along (see left). This will show you the range of tones you can create with this pencil. Now experiment with other grades of pencil and note the differing depth of tones. Over time, with continued sketching and drawing, you will gradually develop full control of applying tones through pressure. Some people can adapt to this very quickly and others can take several weeks, so do not be disheartened if it does not happen quickly; with practice it will.

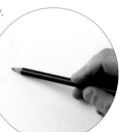

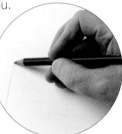

Drawing straight lines.

Drawing is all about trying to recreate a three-dimensional object such as a landscape, a building or a person on a two-dimensional surface. This is achieved by creating shade, light, and shadow by the way we apply the pencil stroke to the paper and also by blending some of those marks. Hatching and cross-hatching is a way of applying sets of lines close together or crossing lines over each other to build up the form and texture of the objects in a gradual way.

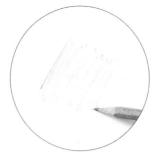 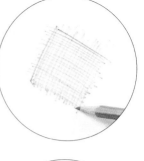

Hatching (above) and cross-hatching (above right).

Smoothing the pencil marks on the paper by blending with a finger or a tortillon (see right) can also help to achieve this effect.

This is a very basic pencil sketch of a footballer using hatch shading. Sketches like this are very useful in the early stages of planning a drawing or painting, as they can help define the pose and the shading.

A more developed sketch, using ink and watercolour. This is still fairly basic but it has more detail and simple little touches of colour.

A very basic sketch using ink, totally lacking in detail but still managing to convey the action pose.

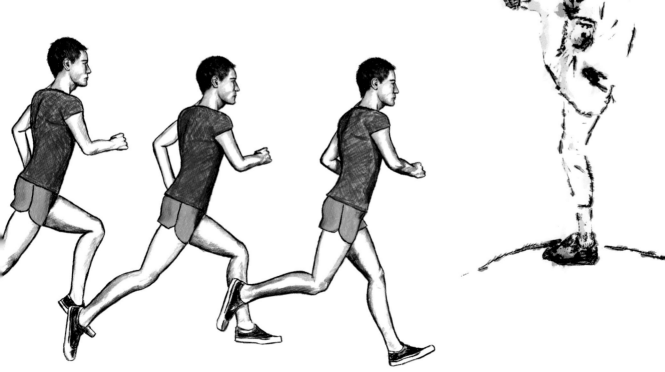

Basic painting techniques

Drawing and painting are often seen as two distinct and very different processes. From my point of view and considering the way I work, I see painting as an extension of drawing and I approach it in the same way. Painting to me is the application of paint by using a brush or palette knife as my drawing tool. When I create a sports painting, I always start with a drawing on my paper or canvas. This drawing will have evolved from initial sketches which I create during the early stages of the process. On many occasions this drawing itself will be fairly detailed and give me a solid foundation on which to progress my painting work. As a sports artist, I know how difficult it is for athletes to get to the top of their game. Constant training and practice contribute to their overall ability and progress. Painting is no different. Only with good preparation, planning and constant practice will you see yourself improve. Do not be put off by poor results – practice does pay off and don't be afraid to experiment.

 I tend to use mainly acrylic paints, acrylic inks, watercolour and pastel when painting.

Acrylic applied thickly

Acrylic is extremely versatile and is well suited to painting figures, portraits and detailed technical work. When these factors are combined with the fast drying speed and the richness of the light-fast colours, then acrylic is a perfect choice for sport artwork. Acrylic can be applied straight from the tube to create a rich, thick texture. If the paint is applied thickly, it can take longer to dry. It is important to remember that when the paint is applied in this way and allowed to dry, it is not easy to correct any mistakes or make any changes without adding more texture and depth to your painting. When I want to achieve a thick, textured painting, I normally start with thinner layers and gradually build up to the effect I want to achieve. This may be a bit more time-consuming but it does give more control of the process.

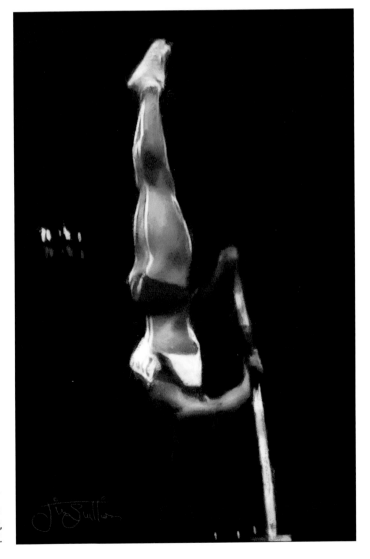

High Pole
Here the rich colours of the thick acrylic help to convey atmosphere and movement, despite the lack of detail.

Acrylics applied thinly

When acrylics are diluted with water, they can be used thinly to lay washes in a similar manner to watercolours. However, they do dry quickly and allow you to overlay washes without disturbing the paint underneath. Thin acrylic washes can also be applied in gradually thicker layers to create both transparent and opaque surfaces to great effect.

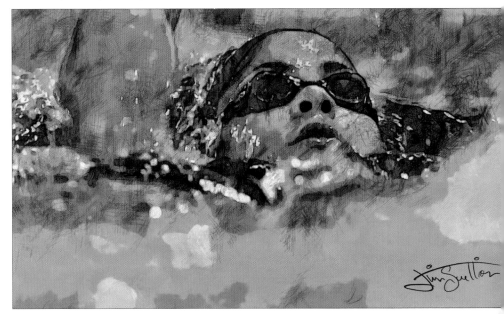

Back Stroke

A fine wash of blue acrylic is used as a base for a coloured pencil sketch. Then further washes of acrylic colour are used to bring up the flesh tones and the surrounding textures and shades in the water. This painting captures the action well yet is not as detailed as it first appears.

Using acrylic inks

Acrylic inks can be applied using brushes, airbrushes or pens. The colours are rich and light-fast and do not require further diluting for use in pens or airbrushes. If diluted with water and applied with a brush, they can produce colourful washes. They are great for expansive colour work and are perfect for adding detail. It is important to remember that they are acrylic and they can damage brushes, airbrushes and pens if allowed to dry in them.

Ice Goal

Acrylic inks are used here to create action and movement in an ice hockey match.

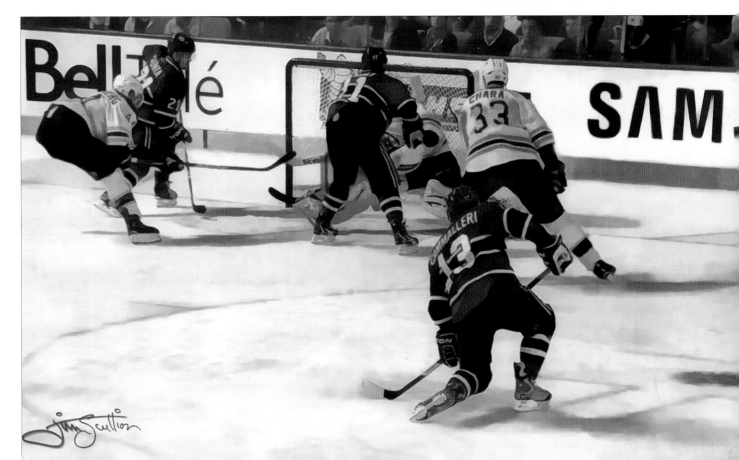

Using watercolour

Watercolour is a real joy to use. It dries very fast and is often unpredictable but it is this unpredictability that makes it fun to work with. Over the years I have heard many reasons why people do not want to use watercolour: you can't control it, it is not light-fast, and you can't make changes to your work. I have found the opposite to be true. Watercolours produce amazing and colourful washes and glazes that are difficult to reproduce using other media. Watercolour blends beautifully with rich vibrant colours and I find that when you use soft sable brushes to overlay glazes on previously dry layers, the soft tips of the brush will rarely disturb the colour of the layer below. When working wet into wet, the effects can be astounding and give a sense of motion and vibrancy often required in portraying sport. By the very nature of its composition, watercolour is also an ideal medium for painting water.

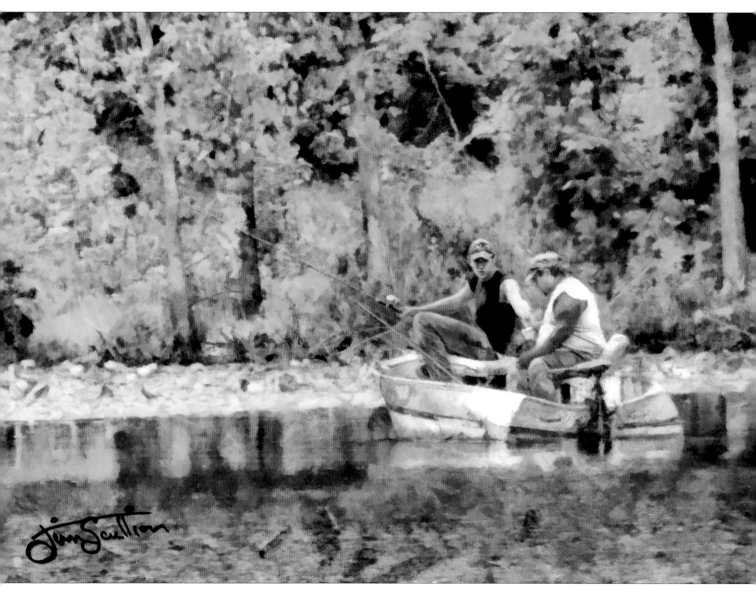

Fishing at Bigfish Lake

I could not resist painting this scene: the colour of the leaves, the reflections in the water and the interaction between the figures. Although it can be a very fluid and unpredictable medium, watercolour can produce some amazing detailed work with a lot of patience.

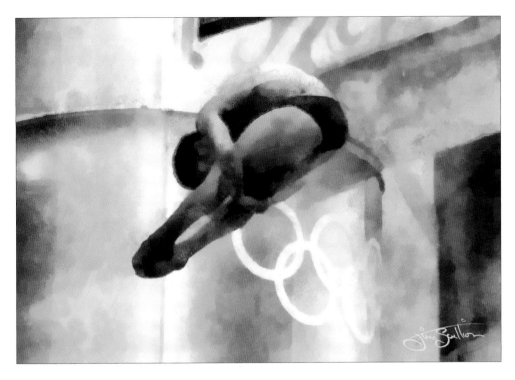

Tuck In

Watercolour is the perfect medium for a subject such as this. The figure is moving and the fluid feel of the watercolour helps to convey the movement while adding to the atmosphere of the event.

Michael Phelps

The US swimmer painted in watercolour. The very loose wet into wet unpredictability of watercolour helped to create the variety of textures in the water, the reflection and the power in this painting.

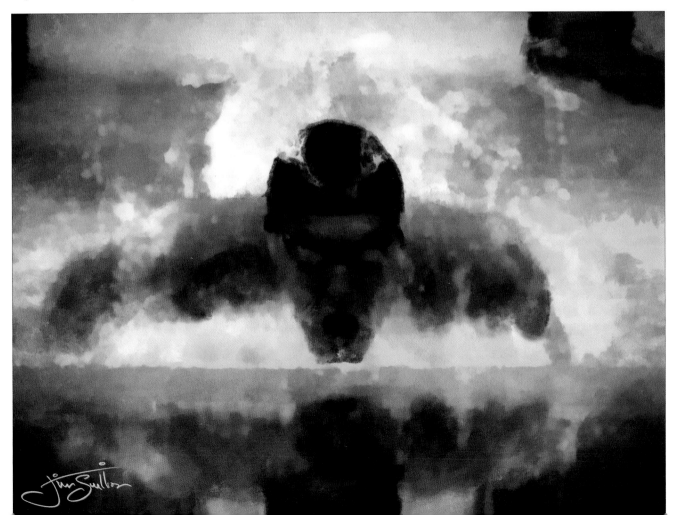

Mixing media

Mixed media artwork is when we use two or more traditional media, such as acrylic and pastel, in creating a body of work. This can be a great way of creating an interesting texture in your artwork. It is important to experiment with different media to see how they react to each other before embarking on a final project. When painting, I am very guilty of continually changing direction and using whatever materials I have lying around. This can produce some interesting and fun results. I particularly enjoy using acrylics and pastels together. They have a different consistency and feel but can work very well when combined in a painting.

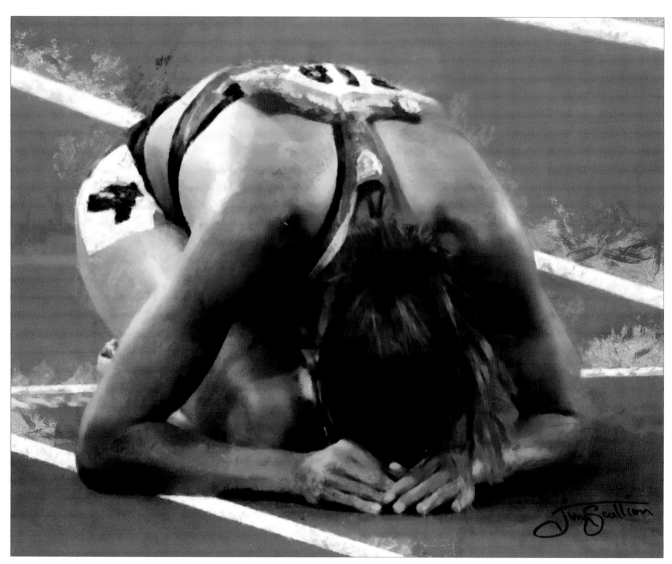

Exhaustion

In this particular painting I decided in the preparatory stages to use soft pastel and acrylic together. The painting depicts an athlete who has successfully completed her event and drops to her knees in exhaustion, with perhaps a moment of silent reflection. The background is made up entirely of the track surface. Working on a white support, I painted the background using a reddish-brown pastel. The pastel was applied in several layers, each of which was blended smoothly into the surface before the subsequent layers were added. This process helped to achieve a really smooth and even background. The white lines were then added using pastel. To add some texture and movement to the background, the white was scraped across it at several points, then removed using masking tape. This lifted some of the background off and exposed the support surface. Both the reddish-brown and white pastels were again used in these areas to help blend in the adjustments. A blue pastel was then used to create a line in the background before it was fixed and sealed using an acrylic fixative spray. The figure was then painted using acrylics.

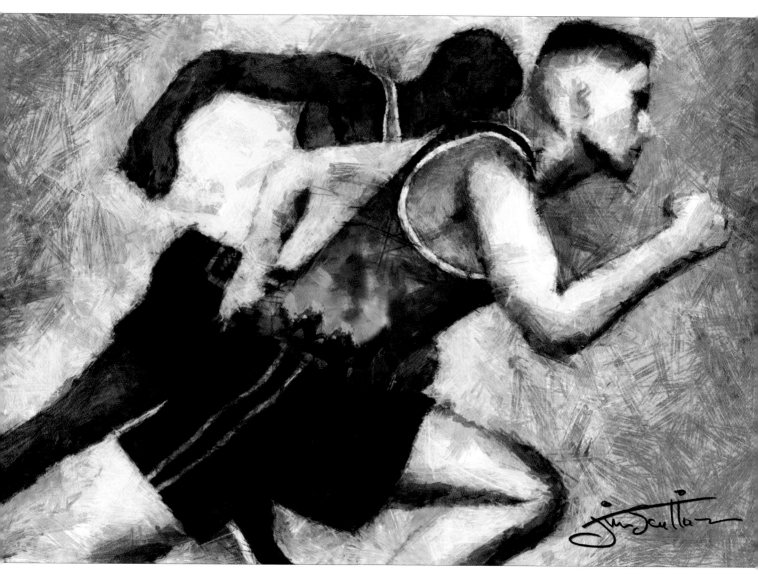

Runners Together

In this painting I decided to use acrylic and pastel together again, but in a very different way. I also decided to add pastel pencils and coloured pencils to the work. This painting depicts two athletes running in a race. I wanted to create an image which would reflect the movement and the excitement of this sport. Initially I painted the clothing and the flesh tones of the figures using an acrylic wash. When this was fully dry, I built up the figures using soft pastel and blending into the surface. This was then fixed with a clear fixative. I then built up the colour using short strokes of hard pastel and pastel pencils. In some areas I added texture by scraping back into the surface of the paper with the side of a scalpel. These areas were again reworked with pastel pencil, and where there was a difficulty in getting the pastel to adhere due to excessive scraping, I used coloured pencils.

Using colour

Colour breathes life, mood, vitality and atmosphere into a painting. Yet adding colour to our work can be very daunting. Adding a colour to a painting because we like it or it looks right is simply not sufficient. Some colours work really well together, and colour mixing comes with practice and with some knowledge of the properties of colours. To help in understanding this, it is useful to use a colour wheel. The colour wheel below consists of twelve colours split into three categories: primary, secondary and tertiary colours.

The primary colours are yellow, blue and red. These three colours cannot be created by mixing other colours. They are pure colours straight from the tube. All other colours are created from them. In the colour wheel I have connected them by lines which form a triangle.

There are three secondary colours: orange, green and violet. Each of these colours is created by mixing two primary colours together: yellow and blue are mixed to create green, blue and red to create violet, and red and yellow to create orange. In the colour wheel, the secondary colours lie midway between the two primary colours used to create them.

Tertiary colours are created by mixing a primary colour with a secondary colour which is next to it on the colour wheel. Yellow and green give us yellow-green, green and blue give us blue-green and so on.

Any two colours which are directly opposite each other on the colour wheel are known as complementary colours. There are three sets of complementary colours, each made up of one primary colour and one secondary colour. These are red and green, blue and orange, and yellow and violet.

When these complementary colours are placed side by side on a painting (not mixed together) they contrast, making each other stand out.

Our colour wheel is represented by the referee's watch to help us to identify the different colours. The primary colours: blue, red and yellow are indicated by the three hands on the watch, at 12, 4 and 8. The secondary colours: violet, orange and green can be found at 2, 6 and 10. The tertiary colours are found at 1, 3, 5, 7, 9 and 11.

By using a fairly limited palette and mixing the colours, you can produce a wider range of colours. By mixing with white, you can create a range of tints, and by mixing with black you can create a range of shades.

Using the complementary colours together in a painting helps to create a contrast and can produce some fairly vibrant and dynamic results. It should be noted then when you mix complementary colours together, they become more subtle and dull down. This is useful when creating shadows. Do not use black to help create shadows as this can overwhelm the colour. Instead use the colour's complementary colour to help darken and create more realistic shadows.

Primary colours

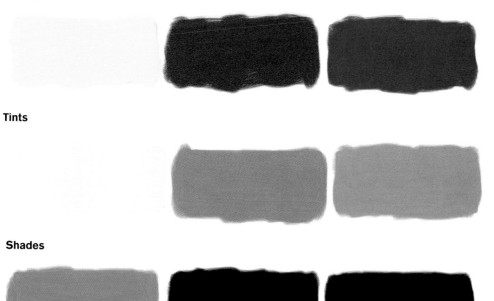

Tints

Shades

In the colour swatches on this page we have our three rows of colour. In the top row we have our primary colours yellow, red and blue. In the second row we can see the tints that are created by adding a little white to the primary colours. The yellow becomes a pale yellow, the red becomes a peachy colour and the blue becomes a bluey grey. The bottom row demonstrates the shades created when a little black is added to the original primary colours. Here we see that the yellow, when added to the black, becomes an olive green; the red becomes a maroon colour and the blue becomes a navy blue. Try adding other colours to these and see what you can create. If you discover a colour that you like, then write down how you created it for future reference.

Badminton

This painting shows both exhaustion and joy at the end of a badminton match. The victors drop to the floor weary, but still the winners. Complementary colours have been used in this painting to help make it very vibrant. The red of the clothing complements the green of the playing surface and the blue background works well with the orange tones in the skin.

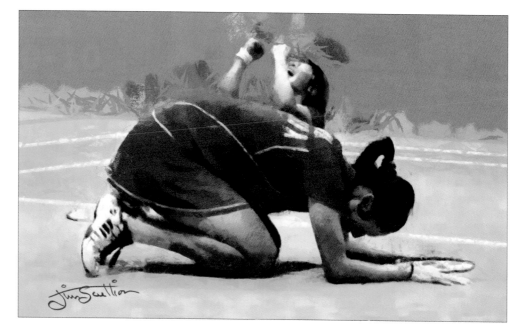

Inspiration

Regardless of what subject an artist chooses to paint, it is vitally important that they are inspired to do so. Inspiration comes from within but often needs to be jolted by outside influences. We are constantly surrounded by great sources of inspiration but we sometimes need to seek them out and recognise them. Over the years I have gathered many items that act as constant sources of inspiration. In my studio I have countless shelves crammed with books, DVDs and magazines. Many of these are art orientated and the others pertain to things I love to paint including sport, movies, music, people and places. As sport plays such a large part in my life, I have a collection of sports memorabilia including blocks of concrete with Muhammad Ali's and Joe Frazier's hand prints in them, a game ball from a Superbowl play-off, Lennox Lewis's boxing gloves, a baseball cap from Mark Webber and masses of football memorabilia. The shelves also hold model sports cars and figures, which are regularly used in helping me to compose my paintings. I also surround myself with music that I like and photographs of my family. Many of my greatest ideas have come directly and indirectly from my wife and sons.

In terms of sport it is invaluable to visit sports stadia and museums and to seek out the work of other sport artists and illustrators. We are constantly bombarded with great sporting images in books, magazines and newspapers and television.

I find it equally important to look outside the world of sport for inspiration. Go to galleries and exhibitions, look at what other artists are doing and what past artists did. This stops us from growing complacent with what we do and helps to inject new ideas and methods into our work. The main thing is to enjoy what you do and share it with the people who mean the most to you.

Do not underestimate the power of the internet when seeking inspiration; we have unprecedented access to literally thousands of artists and gallery sites as well as many social network sites where artists can communicate, offer advice and encouragement and share ideas.

A photograph of a few of the shelves above one of the working spaces in my studio.

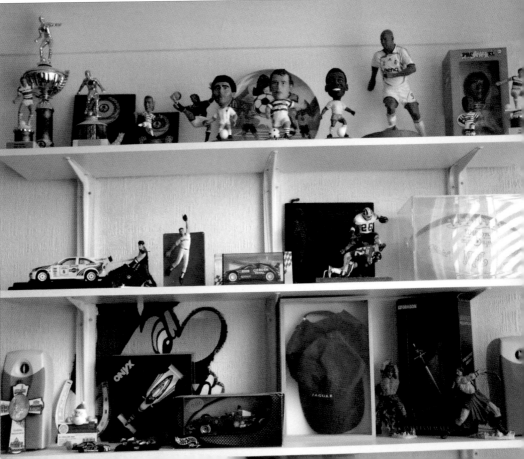

Using your own photographs and sketches

Ever since the invention of photography, there have been artists who have used photographs to help develop their artwork. Although it is fairly common practice today, there is still much debate about the use of photographs. Certainly within sport art, photography is a vital and useful tool. Digital cameras and smart phones have brought photography to the masses like never before, with instant zoom lenses, high definition video capture, differing shutter speeds and settings, in-camera editing and most importantly, instant results. It is now possible for virtually anyone to make a pictorial record of any event or situation. This offers massive reference potential to artists and illustrators.

Photographic references are a great tool to the artist but the most important element is the skill of the artist to use the photographs in an original and creative way. There is not much point in merely slavishly copying a photograph. Photographs can be used to provide a reminder of a scene we actually witnessed; we can use one element from a photograph or combine elements from several to help us develop our painting. The art lies in how you depict and interpret the photograph.

It is important to remember that sport exists at all levels and that when taking photographs for sport artwork, it is difficult to get close enough to the action in major events. However, amateur sports, youth sports and less high profile sports can provide some amazing shots.

Never underestimate the power of sketching. If you are not confident enough to sketch on site, sketch from your photographs and from the television. You will find your basic sketching skills will improve with practice.

Warm-up training

We all know people who as children showed a natural flair for football, or running, who somewhere along the way lost this ability or never got the chance to fulfil their potential. I believe that is true also of artists. I believe that we all have a natural ability to draw when we are children, but somewhere along the way as we grow older, many of us lose or forget this ability. I don't believe that there is one particular reason for this but rather a combination of several factors: learning new skills, finding new interests, lack of guidance, lack of stimulation, or simply growing up. With this in mind, I run workshops for young people to help them progress their interest in art in the hope that some of them will continue to pursue this interest into their adult lives.

No athlete, regardless of their chosen sport, ever fully achieved their potential without ongoing, constant exercise and training. Again I feel there is a parallel with artists. Within my workshops I use warm-up exercises and training to help the participants to develop their skill and understanding as artists. Many of these exercises have been around for many years and some have been adapted and changed for use with young people and with groups, but they are also valuable to use on your own, and you might like to try them.

In today's world of computers, the internet and video games it is easy to see how young people could be tempted away from drawing and painting. It would be naïve of me to ignore this, so computers and games machines play a big part in the workshops. The fast-moving video games which are so popular with young people are brilliant for developing eye and hand coordination. Within the workshops, we use more sedate 'hidden object' games. In these games the player has to find objects which are hidden in a picture crammed full of objects. Sometimes the picture is several times the size of the screen, so the player has to scroll about. Often the clue to the object to be found is a silhouette or outline drawing. This game teaches the player to look and observe.

In relation to sport art, I find it useful on occasions let the kids play a computer game where they have to move to control the game. This gives them the opportunity to move in the same way as the athletes we then go on to draw, and gives them more understanding of motion. I also allow them to draw on computers using art software and a graphics tablet. Using the tablet to draw means that they have to look at the screen rather than their hand when drawing.

As a drawing exercise, I will ask the workshop to practise their sketching by allowing them five minutes to produce stick men in as many poses as possible. I am amazed by the number and variety that they manage to achieve.

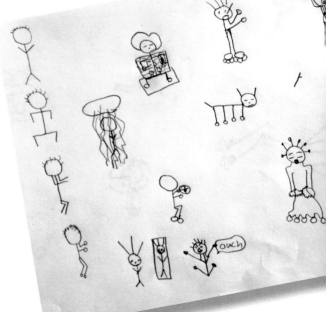

Using the wooden mannequin, each young person takes it in turn to create sports poses and the others have to guess the sport.

The group is split into pairs. Each pair has to sit facing each other and draw their partner – they have five minutes to do this. After five minutes I ask them to do it again but this time not to look at the paper when drawing. After five minutes I ask them to do it again but this time not to look at the drawing and never to lift the pencil from the paper. At the end of the exercise I ask them to sit back to back and write down on the drawing the colour of their partner's eyes. Despite looking at the face for fifteen minutes, they very seldom get the colour right. This is an exercise in understanding not only to look but also to see.

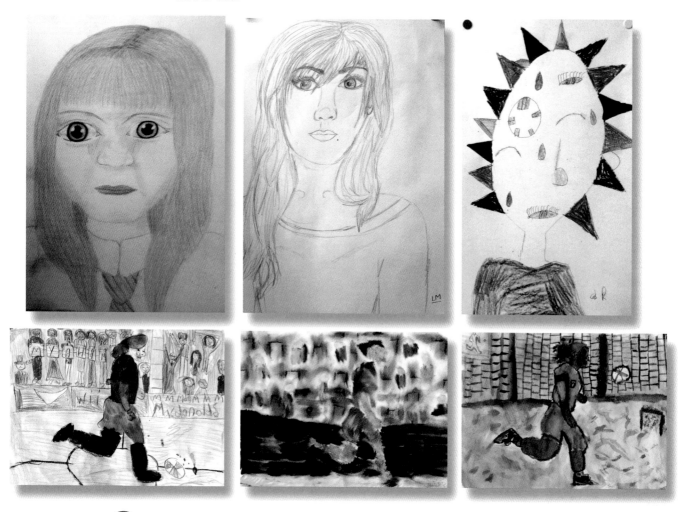

As an extension of these exercises, I get the group to draw an object by looking only at the object, and to draw by never lifting the pencil off the paper.

Another exercise we do within the workshop is to draw with our other, non-dominant hand. By doing this we give up the control we usually have over the pencil, and we produce looser and more vibrant sketches.

These are only a few of the many exercises we do in the workshops. I find young people get bored very quickly so by introducing fun exercises to break up the workshop, I help them to continue engaging, learning and improving their skills.

Anatomy

Figurative artwork, particularly sporting artwork, requires us to portray the human figure in various stages of motion. In order to understand clearly how a body moves, we have to be aware of the body's inner structure. This does not mean that we have to be experts in anatomy, but an understanding of the skeleton and the muscle structure can help us to grasp the dynamics of the human body.

The skeleton

The skeleton is the solid foundation of the body and helps give the body its shape and structure. Look at the skeleton figures below and take note of the bone structure and the joints. Work out how the figure twists and, turns and bends. When we sketch figures, we do not need to sketch a full skeleton but a more simplified structure based on this complex system. It should also be noted that although the male and female skeletons are very similar, the more you study them, the more you realise there are many differences, some fairly noticeable such as the wider hips on the female, and many less obvious such as the slight curve in the female arm and more delicate features on the face. These are very important when portraying the female figure.

It is also important to recognise that the bulk of the body's major internal organs are located above the hips. This can be seen in the sketch of the male skeleton. The weight of these organs also impact on the motion and balance of the figure.

Muscles

There are over 600 muscles in the human body, all with their own purpose, but the ones that are of interest to the artist are nearest to the body's surface; the ones that help determine the shape of the body and power the joints.

Muscles in motion

It is important to understand how the muscles work in groups to power the body and create motion. Certain muscles create a rotating motion, while others create a bending motion.

Look at your own arms and study the effect on your muscles when you bend your arm at the elbow or when you rotate your lower arm while keeping the upper arm still. The more you study anatomy and the major muscle groups, the more you will understand the workings of the body in motion.

This illustration shows the muscles in a female athlete. This figure would be similar to a powerful short distance runner, with strong shoulders and legs and well developed upper body strength.

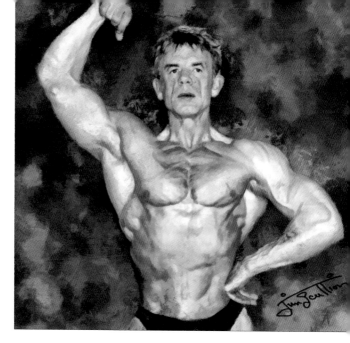

Former body building champion, Andy Gault, painted in acrylic. Andy was so well defined when nearing competition that he was often asked to pose at a local College of Nursing, where he was used as a live anatomy chart. I was fortunate enough to visit the gym run by Andy at his peak and I found all the body builders there really keen to be sketched and drawn.

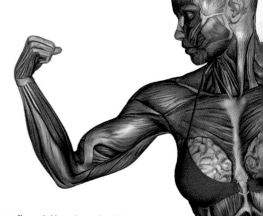

The arm flexed. Note how the bicep muscle in the upper arm reacts to the arm being flexed.

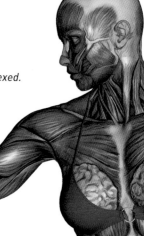

The arm straight and unflexed.

Drawing the male figure

The human body comes in all shapes and sizes. For many centuries the size of the head, from top to chin, has been used as a unit of measurement for the proportions of the body. The normal male is considered seven and a half heads high, however the ideal male is considered to be approximately eight heads high. The ideal sizing tends to be used in figure drawing as it is aesthetically more pleasing. In our example we use the ideal scale.

The height of the male body can be divided by four. The halfway point is just above the crotch, with the top half being further divided at the nipple and the lower half divided just below the knee.

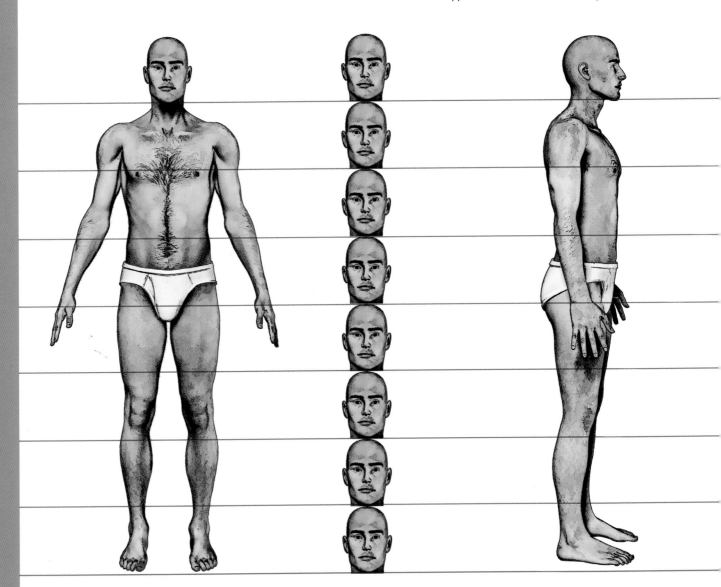

The male figure in sport

The proportions of the male figure in sport differ greatly from person to person as they do in other walks of life. However the sport an athlete excels in can be determined by their body shape or size, for example in the case of a jockey whose sport dictates that he must be very light and, although there are no height restrictions on jockeys, they tend to be around 1.68 metres (5ft 6in) or under. In stark contrast, the sumo wrestler requires body mass to participate in his sport. Training regimes, as well as keeping athletes in top condition, also help to develop the body to cope with the rigours of their discipline. A body builder or a weight lifter will continue to build more muscle and body mass to reach their potential in their sport.

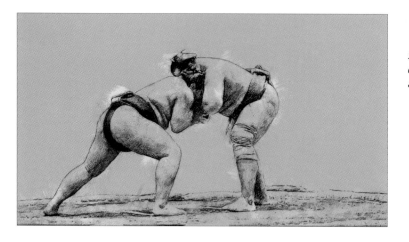

Sumo wrestlers take their body weight to extremes for the sake of their sport, which is all about power and size.

The weight lifter build enormous muscle bulk to the legs and the upper body to help create the ferocious power movement required to lift heavy weights. Many weight lifters are fairly short, which helps in the angle of lifting

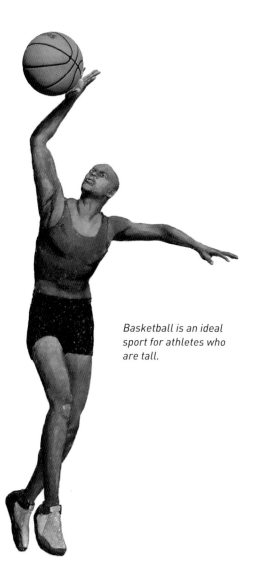

Basketball is an ideal sport for athletes who are tall.

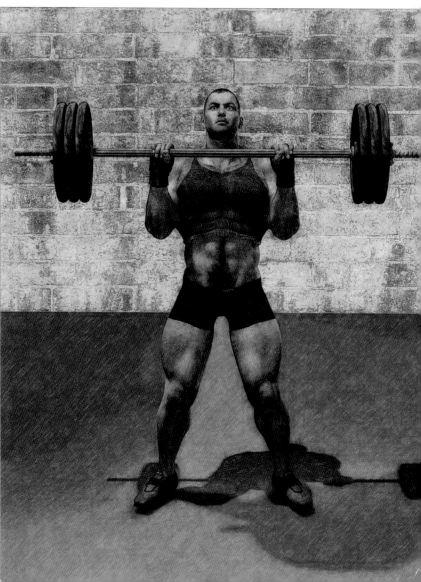

Drawing the female figure

The proportions of the female figure are measured in heads, like the male, and the ideal female figure is also eight heads high. It is important to remember that although the ideal female figure would be shorter than the male, her height would still be eight heads high as her head would be proportionately shorter than the male head. The female figure has narrower shoulders than the male, a smaller waist and wider hips.

The height of the female figure can be divided into four equal parts. The body is halved at the crotch area, the top half is divided at the chest and the bottom half is divided just underneath the knee. This is worth bearing in mind when drawing the female figure.

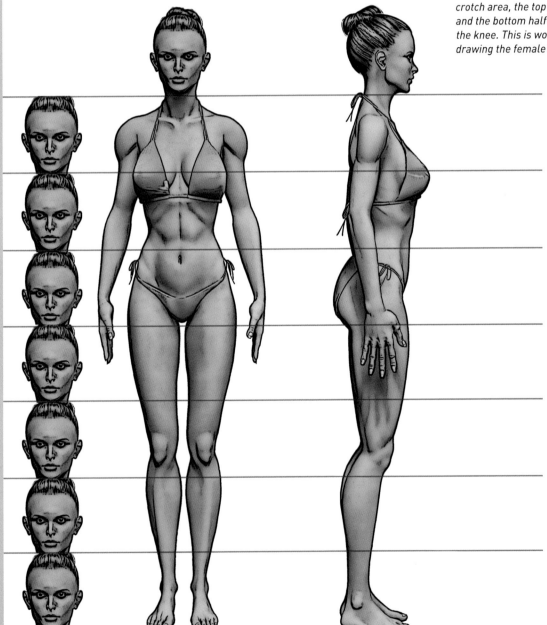

The female figure in sport

Just like her male counterpart, the female figure in sport comes in all shapes and sizes. She too will develop her body to cope with the rigours of her sport. This can be seen with swimmers who have developed wider shoulders and extreme upper body strength, whereas long distance runners can have light frames, stripped of body fat.

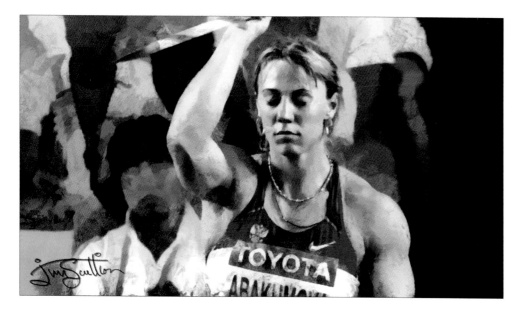

Javelin

This painting of a female athlete preparing to throw the javelin, clearly shows the upper body muscle structure and the power required by the sport.

Swimmers, by the nature of their sport, develop wide, powerful shoulders and legs.

Long distance runners need to be lightweight, but still with very well toned muscles.

Movement

In order to develop a figure in motion, we use what we know about the body's anatomy and make-up. We know that the body takes its form from the inside structure, the bone and muscle. So we will start our figure from the inside. It is not necessary to recreate the skeleton and all the bones, but we will use what we know about the composition of the skeleton to make a simplified skeletal figure much like a fairly detailed stick man. Our stick man has a basic head, neck, shoulders, chest, spine, hips, arms, legs, hands and feet. In the next stage we add muscle and skin to the neck, shoulder, torso, arms, and legs and add facial features. In the final stage we add clothing and detail.

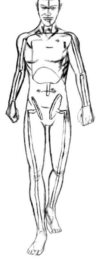

1 We start by creating our basic stick figure. He has the main components of the skeleton: the head, neck, shoulders, chest, spine, hips, arms, legs, hands and feet.

2 In the next stage we add muscle and skin to the neck, shoulder, torso, arms, and legs and add basic facial features.

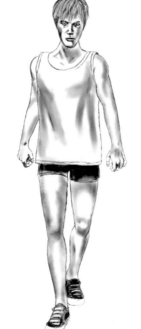

3 In this stage we add clothing, hair and detail.

4 In this stage we build up the tones and give the body a more three-dimensional feel.

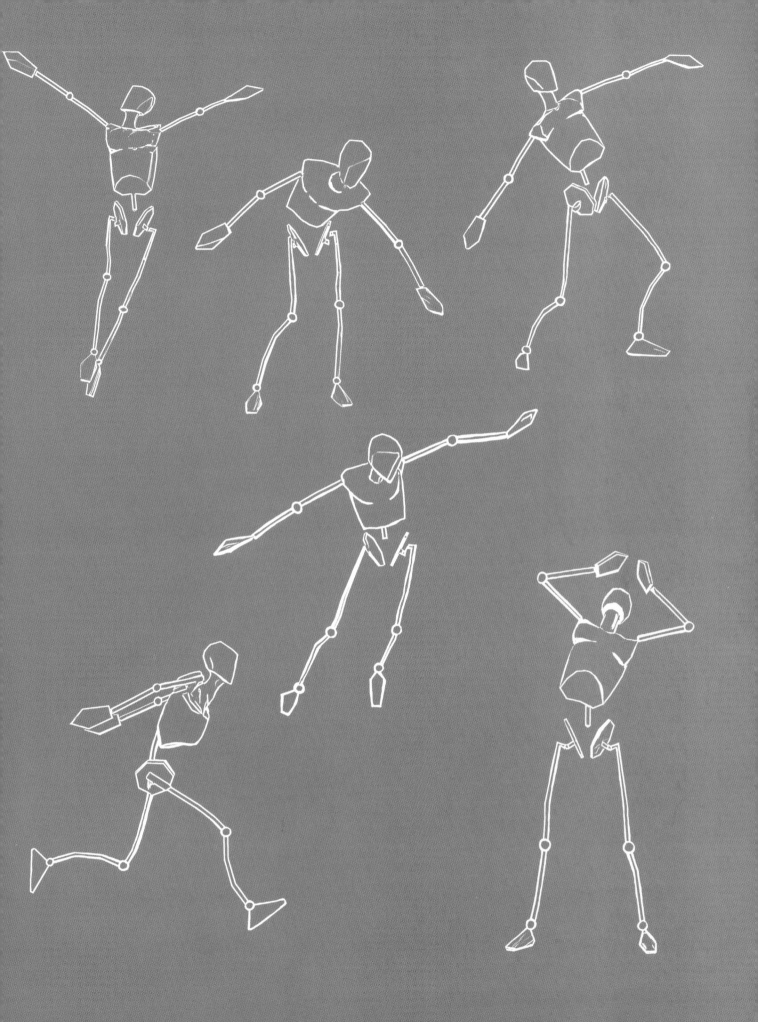

Re-using one pose

Here we have produced a fairly advanced stick man and use several drawings to illustrate how one stick man pose can be developed in many different ways. Try drawing the stick man and exploring even further ways of developing the pose. It may be useful to also revisit the previous stick figures and see if you can further develop and re-use those poses.

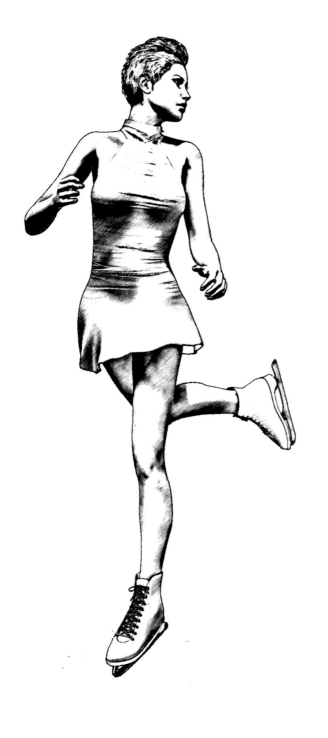
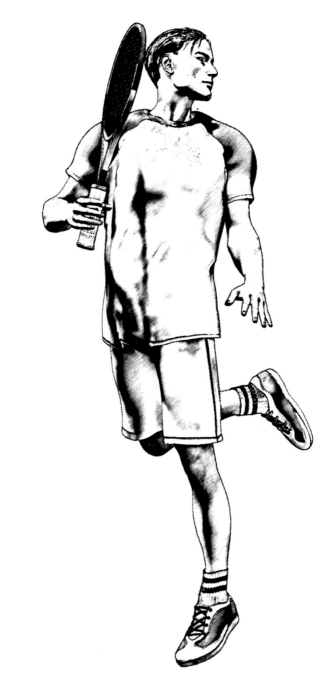

Clothing

When portraying sports figures, we have the added challenge of recreating not only the figure but also the clothing, and the way in which the clothing reacts to movement of the underlying body structure. Athletes wear a variety of clothing as determined by their particular sport. Sporting outfits vary from skin-tight clothing worn by swimmers, gymnasts and some runners to body armour worn by ice hockey players and American footballers. On a hanger, these articles of clothing are of course lifeless, but when worn by an athlete, they come to life, becoming vibrant and accentuating the properties of the body they cover. There are many different types of material and it is important to be familiar with these in order to understand how each reacts to folding, stretching and other movements. Always take note of where clothing hangs from: the waist, shoulders or arms, and also how it reacts at points where it covers joints in the body such as the knees, elbows and hips. Some materials are figure-hugging and cling to the contours of the body; others are freer flowing and will bend and fold and wrinkle. All these elements are important to recreate in your artwork.

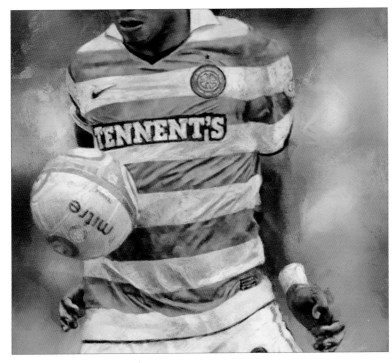

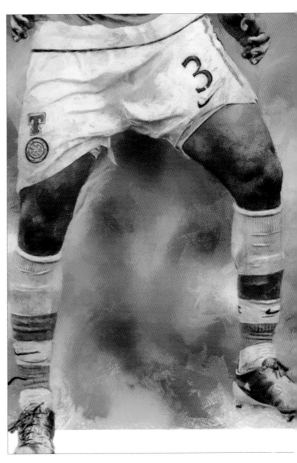

This is a close-up detail of the painting of a soccer player. Here we see the detail of the shirt and how it was created. It is important to note that the shirt is painted in such a way to indicate that it is moving and bending in relation to the movement of the wearer. Like most clothing, we have mid-tones which are more or less the actual colour of the garment, highlight which is where the light hits the cloth, and this is generally lighter and very light at peaks, and the shadows which are darker shades and darkest at the folds in the garment. In this particular painting, we have used various shades of green in the green parts of the garment and in the white parts we have created tones by using Payne's gray and also green to reflect the grass playing surface. When painting stripes and hoops, it is important that the lines follow the contours of the folds and creases in the garment. This helps in making the clothing look more three-dimensional.

This is a close-up from the same painting showing the detail in the clothing and footwear of the lower body. The techniques described on the left are followed through in this section of the painting.

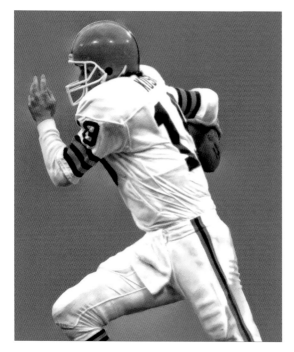

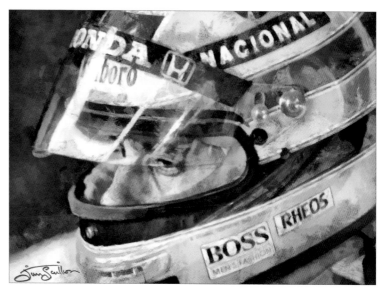

Kosar

This is a fairly detailed watercolour study of an American footballer. His outfit is mainly white, which can be fairly daunting to paint. The shadows are created using a bluish-grey tone. Particular attention is paid to the shadows and definition around the various seams. The lines on his jersey and leggings help to create the textures and movement.

Senna

A close-up portrait of racing driver Ayrton Senna painted in acrylic. The important thing to remember about painting this type of headgear is that it reflects the surroundings. Try not to recreate all the reflections, as often you can see other people, cars or cameramen in this highly reflective surface and these will detract from your painting. Stick to the highlights, as seen here on the clear visor and the side of the helmet. They help give the headgear shape and form without losing the focus.

Venus

In this painting of Venus Williams at Wimbledon, she is wearing a simple but stylish white dress. We do not want to over elaborate it, so it is painted in a simple manner, using very light greys and lilacs as shading.

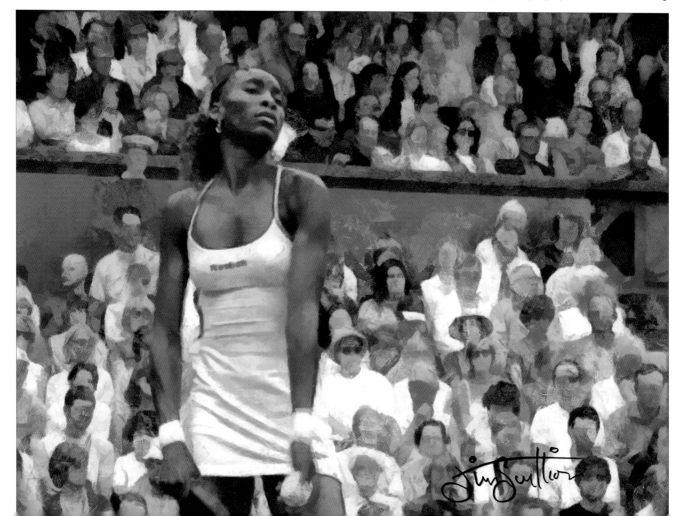

This close-up of tennis player Andy Murray shows how his shirt hangs from the shoulder and also clearly shows the join of the sleeve and the cuff. Take note of the various shades used to create the folds using light highlights and dark shadows.

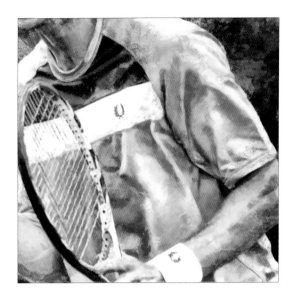

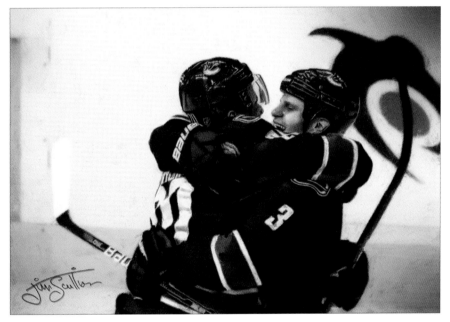

Hug

Two ice hockey players wearing the same uniform. The same principle used to create shadows and folds is used to determine and separate the two sets of clothing.

Boat

This painting shows how shading is used to the extreme to portray different types of material. The top is a rain jacket with a padded life jacket on top and the bottom is rubberised waterproof leggings with a padded area.

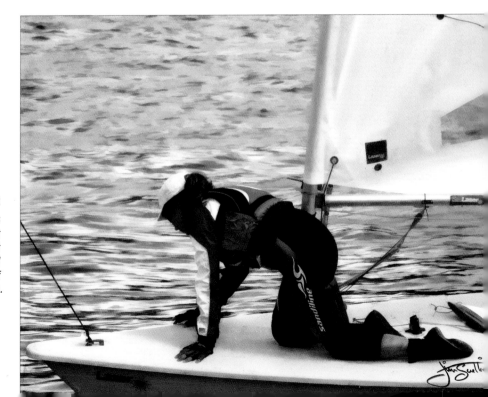

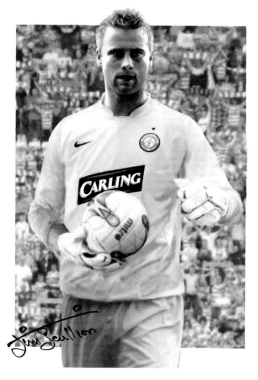

Boruc

This painting of the Polish soccer goalkeeper Artur Boruc was painted in acrylic. The yellow strip has been shaded using orange flesh tones mixed with the yellow. This makes the shading fairly subtle and not too dark. Note that the yellow is also reflected in the flesh tones on his face. The gloves have also been lightly shaded, as too much detail on them would make them overshadow the rest of the painting.

Lewis Hamilton

Painted in acrylic. The padded quality of his driving gear requires much more detailed shading. The numerous sponsors' logos help to define the folds and shape of the clothing in the same way as lines and hoops. Make sure the logos and lettering follow the curves and folds.

Long Jump

Some athletes wear very little clothing, as determined by their sport. It is important to shade them in a similar fashion to the rest of the body so that the clothing does not distract from the figure.

Sports equipment

We have explored clothing for the sports figure and now move on to something equally as important: sports equipment. You only have to wander through any sports store to see the massive range of footwear, headgear, gloves, body armour, bats, sticks, balls, skis, snowboards and countless other items that are available. Recreating these as accurately as possible can be an important part of your sporting artwork. The equipment helps identify the sport to the viewer and adds to the action and dynamics of the completed painting. The equipment can also help to date your subject. I often paint athletes from the past and painting the relevant clothing and equipment from the right era gives the portrait more validity. For example, if I painted a footballer from the 1950s, I would paint him wearing a style of football kit worn in the 1950s, and he would be kicking a ball from that era. Just as clothing has changed in style over the years, sports equipment has changed and developed. Many sports create new styles of equipment for major events, for example each soccer World Cup develops a new ball only to be used in that competition, and so if you want to paint a player playing in a particular World Cup game, then you should portray him with the ball from that competition. This may seem quite petty but sports fans can be quite knowledgeable and will spot mistakes you make. I have had a footballer commission a portrait of himself from me and despite loving the finished work, he asked me to change the boots, as he was now sponsored to wear another company's boots.

Equipment

This illustration shows just a tiny selection of the equipment that is required to carry out various sports.

Armour

This sketch gives us an idea of some of the protective armour involved in American Football.

Coming To Getcha

The armour is for the body but the head also needs protecting in this very physical contact sport.

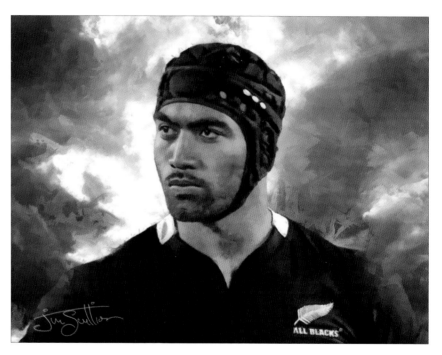

Scrum Cap

The headgear worn by rugby players is designed to protect their ears when in the scrum.

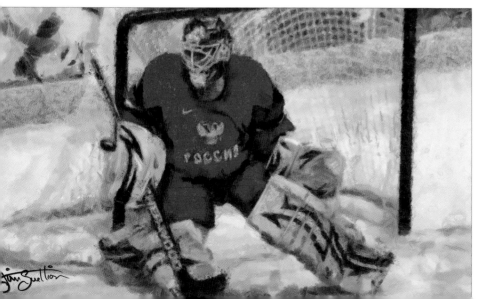

Goalie

Like American Football players, ice hockey players also require body armour, especially the goalkeeper.

Skin tones

I have presented many workshops on painting the human form and the question I am always asked is, 'how do you paint skin?' There is no easy answer to this, and I believe this is the reason many people interested in painting shy away from portraying people. Most art material manufacturers have created flesh-coloured pencils, pastels or paints, but there are many art instructors who frown on the use of flesh from a tube and claim that it makes artists lazy and unadventurous. While I don't fully disagree with this, I do feel that if using flesh paints helps coax more people into painting the human form, then that can only be good for art. I encourage people to use it as a basis and to blend other colours with it to create the flesh tones.

The colour of skin is determined by many things. If we look at light-skinned people, the range of colours is enormous, and the colour is affected by light, the surroundings, the clothing, hair colour and more. When determining skin colours for all ethnic groups, it is important to take all these aspects into consideration, and to work on the shape and dimensions of the face and use tone to help create this.

How to mix basic skin tones

These colour swatches show how to mix skin tones for different ethnic groups. These are only a couple of examples and you should experiment with additional colours to add life and dimension to your work.

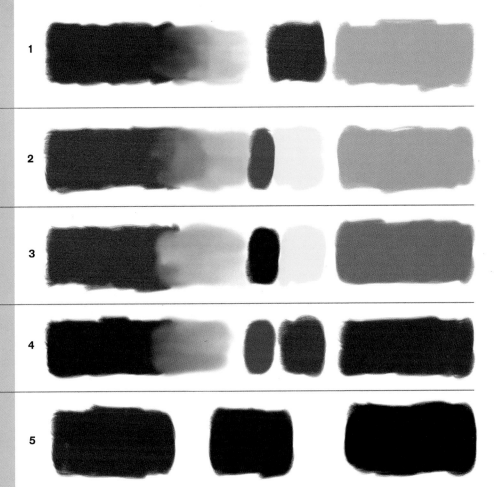

Each row shows the colours that should be mixed to create the final tone at the end of the row. Row 1 shows the creation of a basic mid-tone for light-coloured skin. To create this colour, mix alizarin crimson with white then add a little cadmium red.

Row 2 shows a slightly warmer flesh tone created by mixing cadmium red with white and then adding a little burnt sienna and cadmium yellow. Row 3 shows the formula for creating a warm tone for a darker skin. This is created by mixing the same colours as in the previous row but substituting a little burnt umber in place of the burnt sienna. Row 4 shows how to create a warm tone for a brown skin colour. Mix burnt umber with white and add a little cadmium red and burnt sienna. Adding a touch of blue to the colours in rows 3 and 4 will create cooler versions of these colours. Row 5 shows that by adding burnt umber to alizarin crimson, we can create a colour that is suitable for adding tonal value and shadows to all the skin tones in the previous rows.

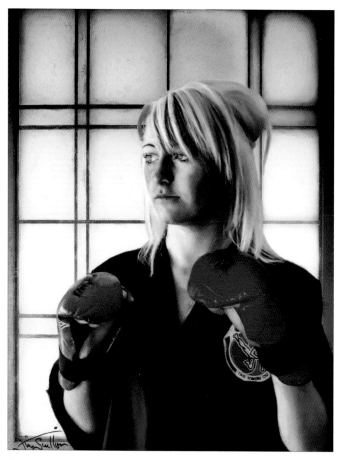

Taekwondo

Laura Jane McGinley, who is sixteen years old and holds black belts in two different martial arts. Her complexion is very light and her skin tones were built up gradually with very transparent washes. The darker tones on her face reflect the light around her and the colour from her gloves.

Before the Race

Two runners prepare for a race at the athletics World Championships. Both have dark skin with a warm complexion.

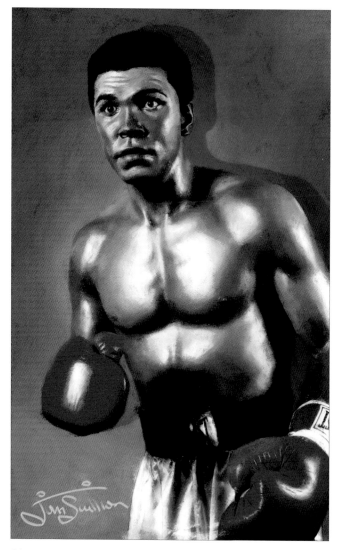

Clay

The warm tones of the young Cassius Clay, later Muhammad Ali, with almost white highlights.

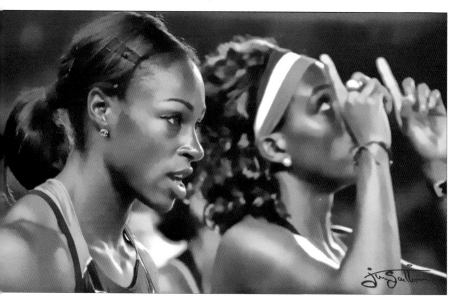

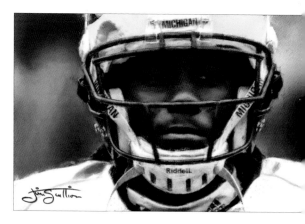

A young College footballer with dark skin. Be careful when painting athletes wearing helmets, as the face can be shrouded by the dark shadows of the helmet. Use brighter highlights in the skin to counteract this.

How environment changes skin tones

The surrounding environment greatly affects how we portray skin tones. This is particularly true in sports paintings. If we take the example of an athlete on a playing field on a warm, bright summer's day, the bright sunshine will cast shadows on the skin, as well as a warm glow. The blue colour from the sky can be used to help create the cool shadows on the face. The green from the grass will reflect on to the skin and the clothing and the clothing colours may also reflect in the skin tones. By using the colours from the surrounding environment in creating the painting of the figure, you can create a more harmonious painting which will be more pleasing to the viewer. It is important not to create figures or portraits in isolation from their backgrounds, as we do not view colours in isolation and the painting will seem disjointed to the viewer.

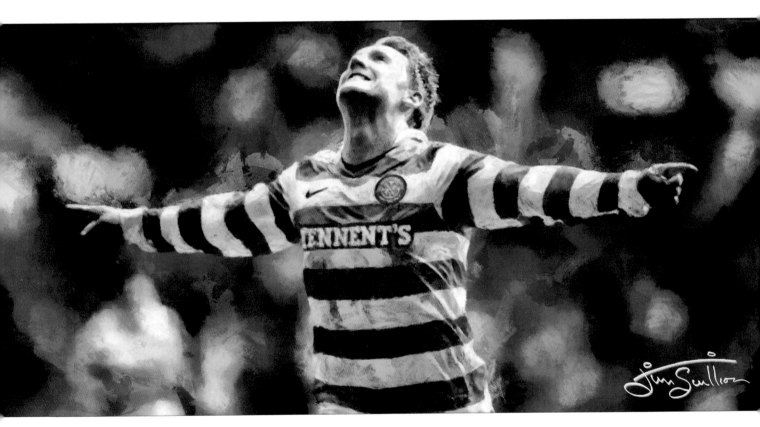

Kris Commons

This painting of Kris Commons of Celtic celebrating after scoring a goal shows how the player's surroundings affected not only how his skin looks but also his clothing. In celebration his face has been tilted up to the sky and direct sunlight, and to reflect this, his face has been painted very light in colour, almost white in places. I added some orange into the shadows under the skin to reflect the warm glow of the sun. Along the tops of his outstretched arms, the shirt and also the hands are in direct sunlight. On the chest and under the arms of his shirt, the shadows were created using green, and a yellowish-green wash was added to the white parts of the shirt in these areas to indicate the reflection of the green grass below him being illuminated by the sun. The use of complementary colours makes the painting pleasing to the eye and well balanced. Little touches of red in the background work with the green in the figure. The blue in the background complements the orange flesh tones and the violet in the background complements the yellow in the background and on the shirt.

Swing

This is a painting of Pete Sampras playing at Wimbledon in brilliant sunshine. His face reflects the warm glow of the sun and his white shirt is shaded in blue to indicate the reflection of the bright blue sky. The flesh under his arms is shaded with green to reflect the lush Wimbledon playing surface.

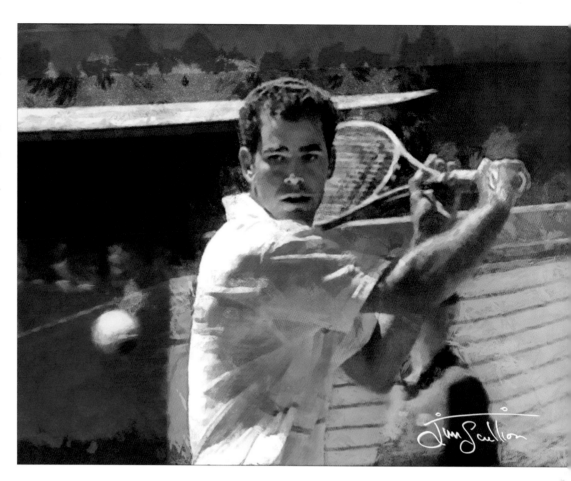

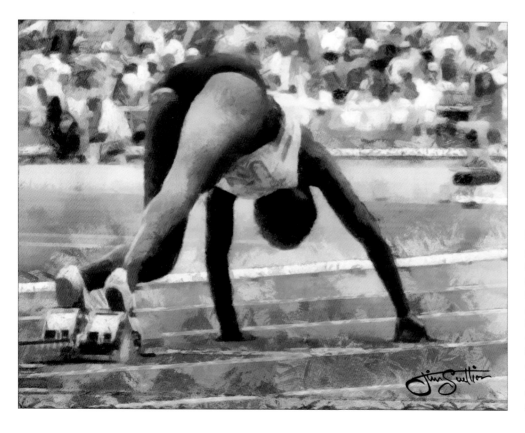

Starter

Everything about this painting says heat. The overall orange and warm red tones are used to reflect the high temperature in the stadium at the time of this race. The crowd in the background lack detail as it should not detract from the main focal point, the runner. However, the orange tones and the white clothing of the crowd add to the stifling, hot atmosphere.

Hands

The hand is one of the most difficult parts of the body to draw. I find that the best way to draw it is by studying and drawing your own hand. If you hold the back of your hand flat in front of you, you will notice that the tops of your fingers form an arc, which is replicated across the joints and then again across the knuckles of the four fingers and thumb. You will also note that the middle finger is roughly about half the length of the overall hand and about the same as the width across the knuckles. These are useful points to remember when drawing hands. If you want to improve your hand drawing skills, I recommend that you draw your own hands in a variety of poses, and from different angles. This is a skill which is very important in sports painting and in painting people in general. In sport, hands can be portrayed in many poses such as pushing, pulling, punching and holding. I have added a few drawings of hands in sporting poses that you can practise copying.

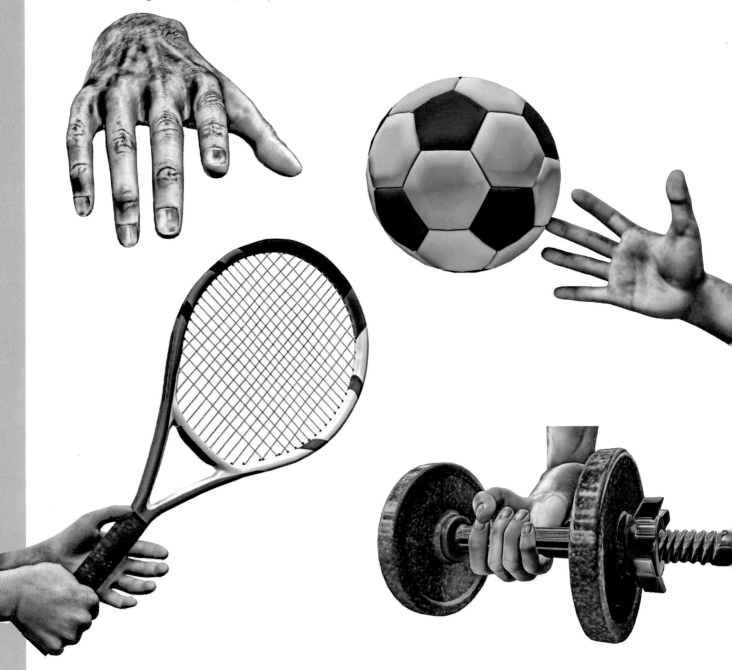

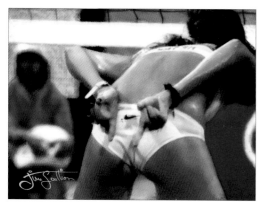

This painting shows the hands being used to give signals to team mates in beach volleyball.

Gerard

The sight that every football fan loves to see. Even if you cover the face in this painting, the hands still tell you everything you want to know.

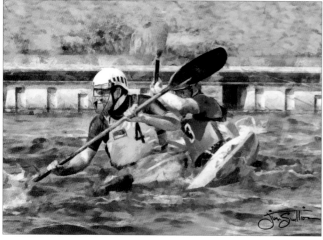

Kayak

Hands are often used to hold on to and grasp equipment in sport. Painting them fairly realistically convinces the viewer that the athlete is holding the oars, which adds to the action in the scene.

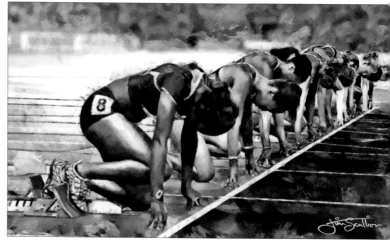

On Your Marks

This painting shows the importance of the hands in running. They are placed on the starting line before the race and along with the arms help to power the body around the track.

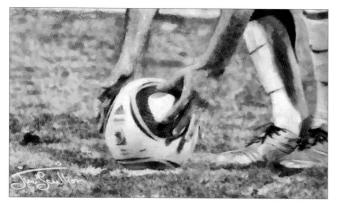

Penalty

This painting is all about the hands. The few seconds that it takes to place the ball on the penalty spot is one of the most tension-packed moments of any soccer match.

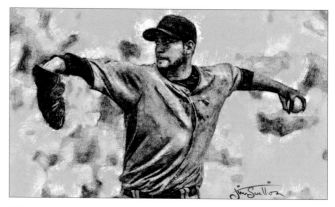

This charcoal and chalk sketch really shows the hands at work in baseball. One is covered with a catcher's mitt and helping the body to balance in preparation for a throw, and the other grasps the baseball ready to propel it.

Faces

Before we draw the face, it is important to look at the dimensions of the head as this helps us in placing the features in the right place.

In the drawing of the head from the front we can see that the head can be divided in four equal horizontal sections from the top of the head to the chin. The top section goes from the top of the head to just below the hairline. The next section extends down to the eyes which lie halfway down the head. The next section goes from the eyes down to just above the lips. The vertical lines in the illustration show that the nose is roughly the same width as an eye and the eyes are roughly one eye width apart. The mouth is roughly the same width as the distance between the pupils of the eyes, and the ears are in line with the top of the eyes and the bottom of the nose. Please remember that this is a guide to help in sketching the face and that many people's facial features do not fully fit this template.

The second illustration shows the face in profile, from which we see that the ears lie just over halfway across the side of the head.

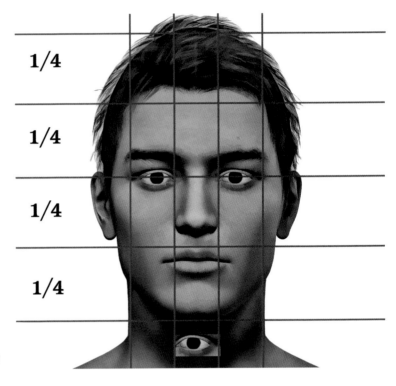

1/4

1/4

1/4

1/4

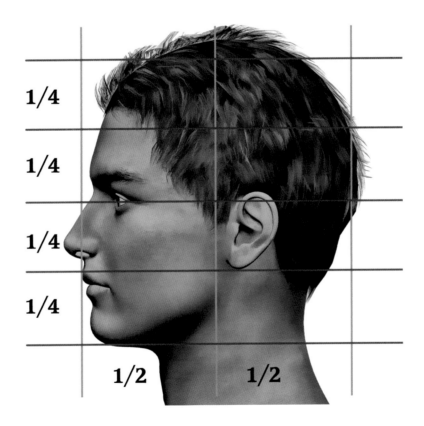

1/4

1/4

1/4

1/4

1/2 1/2

How to shade faces

In this example we create a detailed sketch of Swedish soccer star Henrik Larsson. This drawing was completed on Bristol board using only a 3B pencil and a tortillon blender (made from rolled up paper).

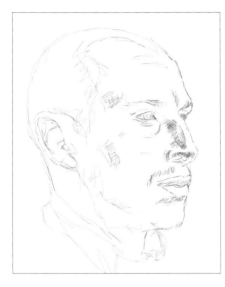

1 We start with a rough sketch of Henrik. There is some rough hatched shading added around the nose on the cheek and to the left of the eye.

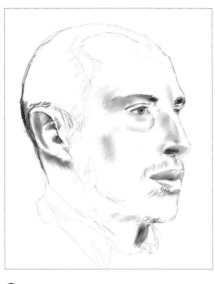

2 At this stage the rough shading has been blended into the paper and some detail has been added.

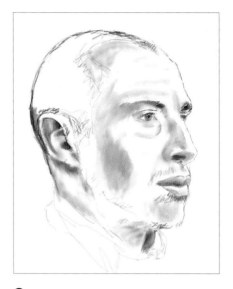

3 More shading has been added and blended. The shading is deliberately added in small areas at a time, then blended. This allows greater control of the overall effect. More detail has been added. This is about two hours into the drawing process.

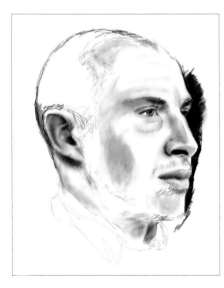

4 More blending has occurred and additional detail has been added as well as some dark areas around the outside of the profile. The shading is becoming more realistic and giving the drawing dimension. This is noticeable around the ear and nose.

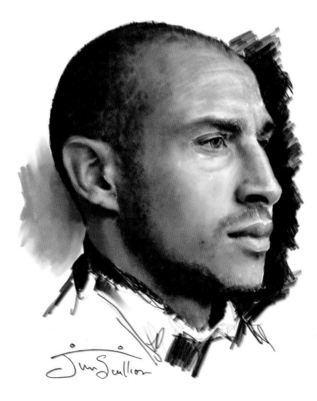

The final portrait. The final blended surface gives a realistic feel to the overall drawing. Highlights were lifted out with a kneadable eraser. The total time for this drawing was about six hours.

How to add colour to faces

Adding colour to a face brings the artwork to life. It is vital to remember that painting a face is very similar to drawing a detailed face – we need to pay attention to shading and light to help give the face a more realistic feel. Pay attention to the surroundings, as they also impact on the flesh colours, as does the background that you choose. In this example I paint a quick portrait of tennis legend Steffi Graf. I used acrylic paints in this exercise with a fairly limited palette of colour for the skin tones including titanium white, cadmium red, cadmium yellow, Prussian blue, black, crimson and burnt umber.

1 I started with a fairly detailed sketch of Steffi in pencil.

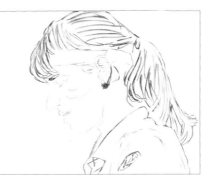

2 When transferring the drawing to my support for painting, I used coloured pencils because they blend better with my paints and do not muddy the surface.

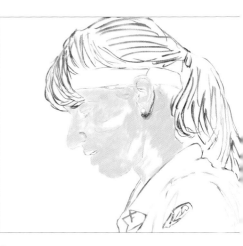

3 I added colour to the face by painting a mid-tone flesh colour mixed from titanium white, cadmium red and a touch of cadmium yellow.

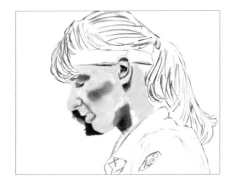

4 I then added some detail to the eyes and the ears using burnt umber, and also some dark colour around the outside of the face using burnt umber with a touch of black. I applied a mix of burnt umber and Prussian blue to the cheek and the neck area, and immediately used a large dry brush to blend this in.

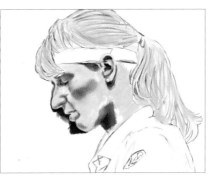

5 I added a mid-tone for the hair mixed from cadmium yellow and a little burnt umber. The dark colour outside the face was extended around the nose and forehead profile. I added more of the burnt umber and Prussian blue mix around the eyes, mouth, nose and ear, and immediately blended this in. The shading was now helping to sculpt the face.

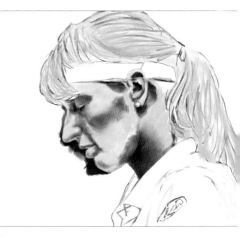

6 I continued adding the darker shadow mix to the face, behind the ear, across the cheek and the neck and again blended this.

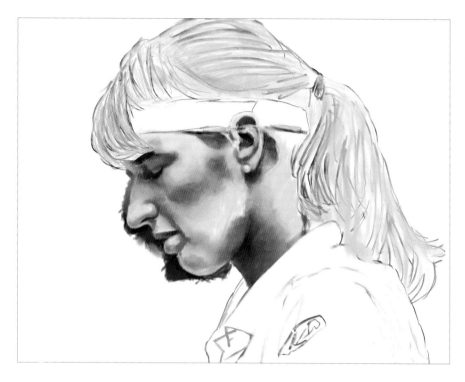

7 This stage shows how the blended colours have gradually built up the tones on the face. This is a lengthy process and takes much patience but is worth the effort in the end. I added an orange mixture made from the red and yellow on the forehead, the chin and above the eyes, and blended this. This is an indication of reflective colours from outside the painting area.

The final painted image. The shirt is painted with blue washes to reflect the sky and the background has been painted roughly with flesh tones and dark tones to create the impression of an out of focus photograph, giving the figure more dimension. Blue has been used throughout this painting, in the shirt, the background, the bandana and extensively in the mixture for the shadows of the face. Orange has been used in the hair ribbon and the bandana and in the blending around the eyes, forehead and the fringe of the hair. As you may recall, blue and orange lie across from each other on the colour wheel and are therefore complementary colours. These colours complement each other and make the painting more pleasing to the eye.

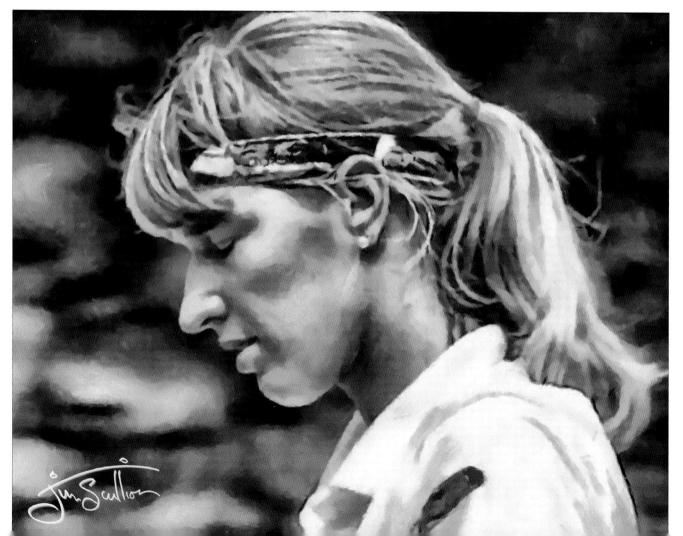

Expressions and emotions

Just as the underlying muscle structure plays a major part in the movement of the body, it also plays a major role in the movement of the head and face. The muscles in the face allow a degree of facial movement which creates a variety of facial expressions. As these muscles work together, they create subtle movements across the face. For example when we frown, the mouth and lips arc downwards, which we recognise as a frown. However, during this process the chin, cheeks, eyes, brow and forehead also move. Look at your face in a mirror and frown; you will notice the subtle changes that take place across your face. If you place the palm of your hand lightly across the whole of your face and then frown, you will feel the muscle tissue under the skin make slight movements in the various parts of the face. If we draw a mouth on a face with a frown and ignore the other movement in the face, the result will be fairly unrealistic.

Facial expressions are important in sport art. Expressions convey emotion in your paintings which is important when trying to portray every type of feeling from the nervousness of the start line to the joy of victory and the despair of defeat.

Try copying the drawings below, paying attention to how the expression affects the whole face.

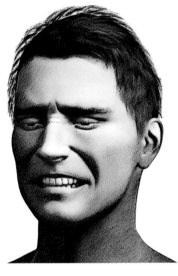
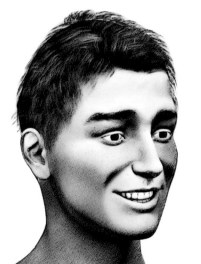
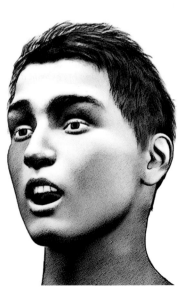

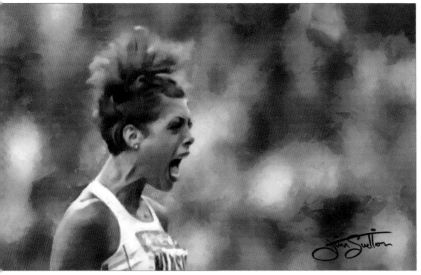

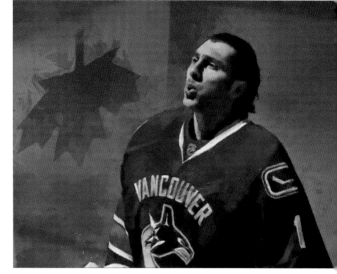

Scream

Sometimes it is impossible to hide the delight of a good performance.

Oh Canada

Athletes proud of their roots and their country often participate in the national anthem before competing.

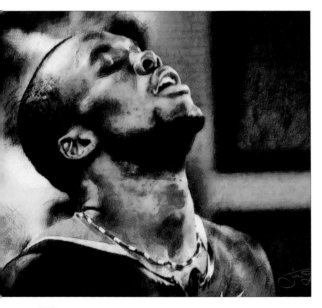

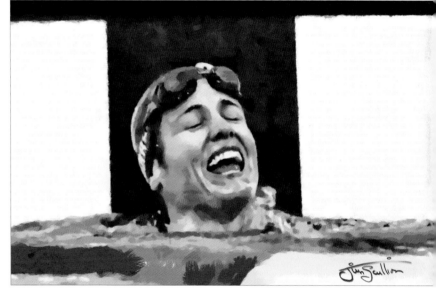

Winner

Sometimes it is not easy to work out the feelings from the expression. Is this athlete relieved to have finished the race or is he closing his eyes in disbelief? I prefer to believe that he is saying a prayer of thanks.

Smile

Swimmers often don't know how well they have done in a race until they turn and look at the scoreboard. The expression says it all.

Tongue

The New Zealand rugby team use a traditional dance with great facial activity to welcome their opponents before the start of a match.

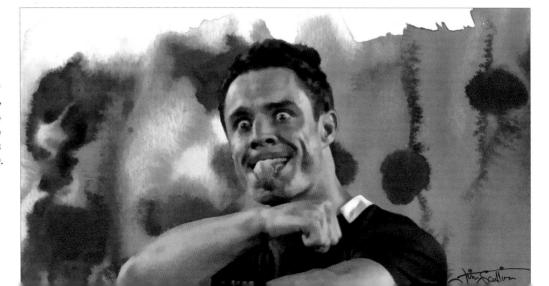

Perspective

When we draw or paint, we do so on a flat, two-dimensional surface. The artist's task is to make the drawings and paintings we create look three-dimensional on this flat surface. The use of perspective helps us do that. Perspective helps us to create dimension and also a feeling of space, allowing us to determine how close or how far away objects are. If we draw a box face-on, we have a square; when we move the box and draw it in perspective we have a cube. In order to illustrate this simple perspective in figure drawing, I have drawn the wooden mannequin but replaced his head, chest and hips with boxes in order that we can see the three-dimensional effect more clearly.

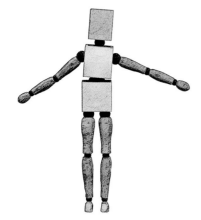

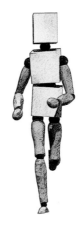

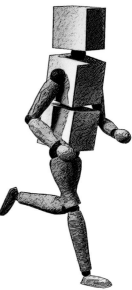

In this drawing we look at our figure from the front. The boxed areas are represented by rectangles as we can only see one flat plane.

We are still looking at our figure from the front, but now we have drawn him running. The boxed areas are still mainly flat rectangles. However, this drawing shows that the boxed areas have moved and illustrates how the head, chest and hips have been affected by changing the pose. You can clearly see that the chest and hips have tilted at opposite angles to counterbalance each other.

Looking at the same running pose from the side, we now see the boxed areas in a more three-dimensional way as we can see more than one flat plane of the box. This drawing also illustrates the movement of the head, chest and hips but from another angle.

In this painting there are numerous lines which help with the perspective; the illusion of depth and space. The church is made up of boxed and geometrical shapes and as the top of the roof angles downward towards the back of the painting, the line at the bottom of the wall angles upward. This results in the back of the church seeming to be smaller than the front, which gives the illusion of depth, as objects appear smaller the further away they get. This is also illustrated with the figures. The two boys on the right are much smaller than the other two figures, which creates the illusion that they are further away. This is further reflected in the different sizes of the trees in the foreground and the background. The white line of the sidewalk which cuts through the lower half of the painting at an angle helps to add to the illusion of depth. Another way of creating depth in artwork is to overlap objects, which helps to determine which is nearer. Here we see that the large tree at the front slightly overlaps the edge of the building, and the building overlaps the trees at the right-hand side. The shadows, tone and detail all help to add to the overall effect.

Foreshortening

Foreshortening occurs when a figure is moved from a still standing upright position to a new pose. This gives the effect of parts of the body nearest the viewer being larger than the parts further away. Foreshortening can be a useful way of creating action in a figure and helps bring the viewer closer to the action.

We return to our boxed mannequin figure, and he is drawn lying down. The foreshortening in this drawing shows his feet to be much bigger than the rest of his body, with the body reducing in size as it moves further away from the viewer. This is an extreme example of foreshortening.

In this drawing we are looking at the soccer player from the front and slightly above him. The left hand is slightly bigger than the right, which gives the impression that the right arm and hand are nearer the viewer.

We are now looking at the same pose as before but from the rear right-hand side. The right foot and right arm now appear to be larger, giving the impression that they are nearer the viewer.

This is a view of the same pose drawn from the left-hand side just above the figure. This is an example of extreme foreshortening; the viewer can almost touch the left hand, which dominates the scene, being much bigger than the feet and even the head. The viewer could not get much closer to the action in this drawing. If you look carefully at the legs and feet in isolation, they look totally out of scale with the rest of the figure, but they work well when we view the figure as a whole. It is important to remember when drawing figures in action poses that our preconceived perceptions of what body parts look like will be challenged by foreshortening. Only with practice and experimentation in your work will your skill and confidence grow.

Composition

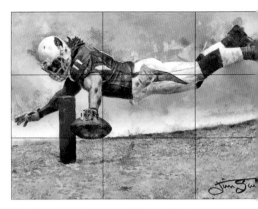

Before embarking on a painting, I prepare quite thoroughly and the first thing that must be identified is the composition, which basically means what will be in the painting and how will it be portrayed and arranged. It is not as simple as having a good idea and then just painting it; you need to make the painting pleasing to the eye. You want the viewer to understand what you are trying to portray without having to work it out for themselves. Different objects in a painting can be placed in order of importance depending on how you place them or size them. For example, you may want to concentrate on a particular person, and would portray them centrally and large to dominate the scene. I use thumbnail sketches to help me decide where to place the main elements of my paintings and to determine the rough values and shading of the work.

The rule of thirds is a compositional tool involving dissecting your artwork into nine equal sections using a grid consisting of three horizontal and three vertical lines. It is believed that placing the main elements of your painting along these lines or on the points where they cross, will give it a more dynamic composition, which will hold the attention of the viewer.

This illustrates the rule of thirds. The figure in the painting lies along the top line with his arm following closely to the right-hand vertical line. His body and the ball also lie on three of the intersections where the lines cross. This painting has been fairly closely cropped around the figure which adds to the drama and action.

The rule of thirds grid when added to this sketch shows that the ropes of the boxing ring follow quite closely the lines of the grid and the main elements of the sketch lie on the intersections.

This is a small thumbnail sketch approximately 7.5cm (3in) across. It has two purposes: it allows me to plan where I want to place the main elements of my painting and it is also a value sketch to determine roughly where the shadows and tones will lie in the painting.

This is a cropped version of the thumbnail which shows the main components of the paintin: the boxers, totally dominating the scene. This would provide a drama-packed painting, concentrating on the action. Personally I prefer the previous version, as there is more of the background and the boxers dominate the centre and the right-hand side of the picture, which helps emphasise that the boxer on the receiving end of the punch is being driven back by the blows.

Adding backgrounds

Backgrounds can make or break a composition. It is important to work out in the planning stages what style of background we want and what we are trying to convey in the painting. A background that is too busy or too detailed can distract from the main subject of the painting. Similarly a background that is too plain or sparse can leave our figure looking isolated and lost. A background can add tension or excitement or place our figure in context. The use of complementary colours in a background can help to make a painting aesthetically pleasing.

This is a drawing of the negative space around the figure of a gymnast. This is a useful exercise in understanding shape and layout. Too often we concentrate on the positive shape, the figure itself, and ignore the area around it. The negative space helps us determine where to place a figure, and is vital in helping us to create a background that leads the viewer to the main subject and does not dominate it.

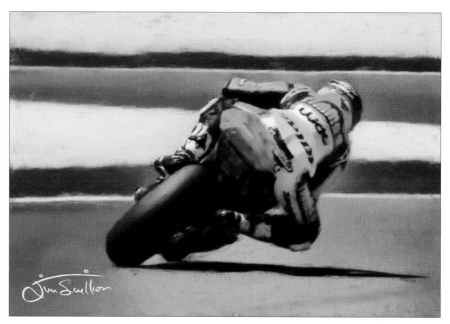

This painting has a very simple background with little detail, but there is enough there to place the bike rider in context. It is fairly obvious that he is on a racetrack.

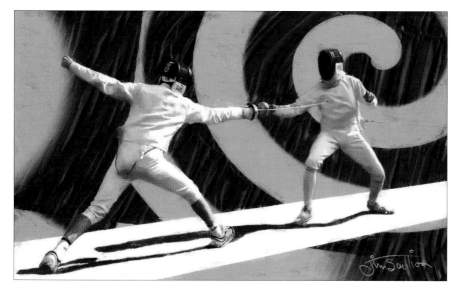

Fencing

Even in serious competition, fencing can have a fairly clinical and boring backdrop. In this painting I have added a bit of colour and movement, recreating the swirls and thrusts of the action involved in the sport.

Atmosphere

As a child listening to football on the radio, I was enthralled by the words of David Francey, the commentator who described the whole event with incredible detail and clarity. Sports commentators of that era such as Harry Carpenter (boxing), Dan Maskell (tennis), Bill Mclaren (rugby), Peter O'Sullivan (horse racing), Murray Walker (Formula One) and Archie McPherson (football), to name a favourite few, were a very special breed. They did not merely report the sporting action but described in detail the whole scene, and in doing so helped create the special atmosphere of the event. When I first went to a senior football match at Celtic Park, I missed the first five minutes of the game as I was waiting for David Francey's voice to describe the action for me. I was fortunate enough as an adult to paint David and we became friends until his sad passing early in 2011.

What I want to create in my sport paintings is the very same thing that David and the other great commentators mentioned above were able to create in words: atmosphere. I feel that this can be achieved by adding emotion to the paintings, in the form of colour, movement and celebration.

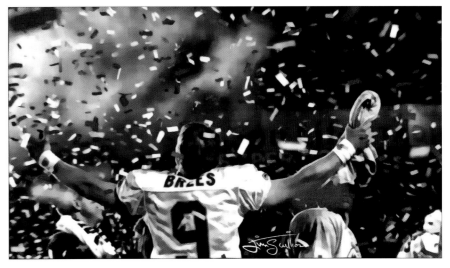

Superbowl

This is probably one of the least action-packed moments in American Football's grand spectacle, the Superbowl. However, it is the moment all fans dream of, when the confetti is cannoned into the air and the winning celebrations begin. The obvious excitement of winning quarterback Drew Brees adds to the overall atmosphere.

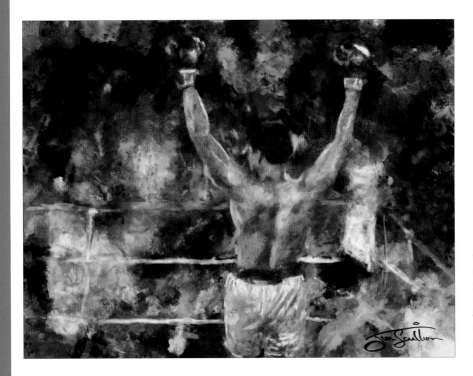

Ali

One of boxing's greatest ever nights, the Rumble in the Jungle in Zaire, 1974, between George Foreman and Muhammad Ali. This painting uses colour to help create the atmosphere. There is virtually no detail in the painting, but enough for the viewer to recognise 'the greatest'.

Comerica

Personally I find one of the most enjoyable things about sport is arriving at the stadium shortly before the event starts; there is always an air of excitement and expectation. This is particularly true when approaching a venue that is new to you. This watercolour painting shows the entrance to Comerica Park Baseball Stadium in Detroit, the home of the Detroit Tigers. The actual façade with its giant baseball bats and massive stone tigers really gives you a feel for the entertainment you are about to enjoy.

Vuvuzela

One of the main ingredients of atmosphere in sport is the fans and their participation. The South African soccer World Cup fans introduced the vuvuzela to the world and added a new dimension of spectator participation to the game. As this very sketchy painting shows, they added fun and colour to the proceedings along with an annoying drone.

A pretty wet and dismal day at the races, reflected by the muted colour and grey tones. The colour of the horses and the jockeys still manages to inject an air of excitement into the occasion.

Steam

This painting attempts to capture the action during a wet and windy evening game of rugby. There are a couple of little paint strokes in the background to highlight umbrellas and let the viewer know it is raining. The power, determination and sweat of the players combined with the cold, rainy atmosphere have created a cloud of steam above the scrum.

Sport and machines

From the one or two horsepower chariots of ancient Rome to the 700 plus horsepower chariots of today's Nascar and Formula One, machines have played a major role in sport. When exploring the world of sport art, we cannot forget the quest for speed on land and on water. As a young boy I lived next door to a soccer stadium which was transformed on a Sunday into a stock car racing track. Fortunately I was able to stand on the table in the living room and watch the cars race around the track. I spent many Sundays on top of that table, until the stock cars were replaced by speedway. The popularity of the speedway led to a new fence being built which obscured my view and put an end to my table-top antics. However, the incredible roar of the motorcycles, the loud music and the cheers from the crowd were more than a young boy could bear, and so scaling the less secure parts of the fence became a weekly adventure for my friends and me. The reward was amazing; I can still remember the smell of petrol, the deafening engines and the clouds of dust as the motorbikes sped their way around the track. My love of motor sports was born. When drawing in the evenings, I now drew not only footballers but also speedway.

Painting motor sports brings its own challenges. Much of the work is fairly technical and more prescriptive than painting people. I watch the races, take photographs and watch video images over and over to help me with the detail, and often I will use models in the same way as I would use a mannequin for drawing people, to help me determine proportions and angles. Perspective is also important in motor sport art, as it helps to create a sense of depth, motion and reality.

It is important to remember that often the machine itself is the focus of attention for the fans rather than the athletes who control them. You will understand what I mean if you are ever in an airport or a shopping mall when a real Formula One or Nascar car is on display for a promotional event: you will see a group of grown men standing around it salivating.

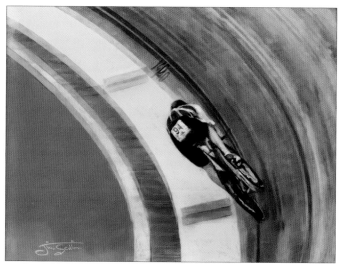

Bike Ride
Painted in watercolour. This is a fairly simple painting, lacking in any great detail, but it still manages to capture the essence of the sport.

Nascar
Painted in acrylic, this painting captures the intensity of racing at enormous speed around a tightly packed track.

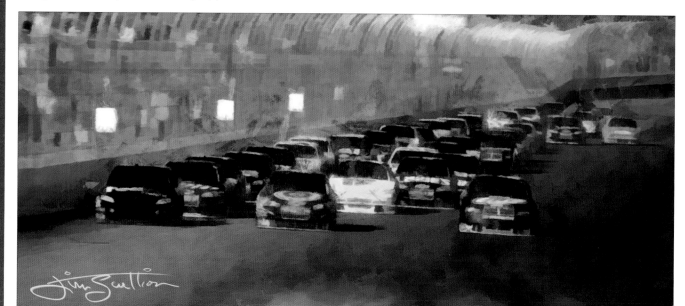

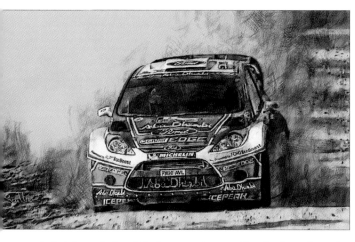

A sketch created on tinted paper using pencil and coloured pencils. The use of this medium helps the viewer to see what actually isn't there: the sand, the dusty track, the billowing smoke.

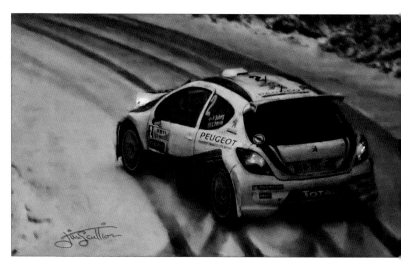

Snow Rally

The later stages of a rally in the snow painted in acrylic. The bright brake lights indicate that it is getting dark. By simply dry brushing darker shades over the light, we are able to create the illusion of snow.

Vettel

Painting of Sebastian Vettel created in acrylic. This is painted at very close quarters, which adds a sense of drama to the painting.

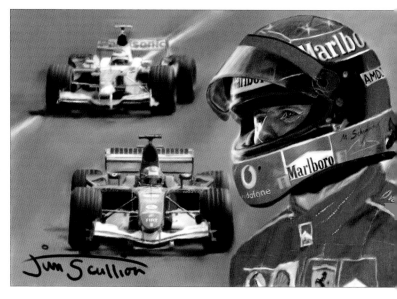

Schumacher

Michael Schumacher created entirely in soft pastel. Pastel, when used carefully and with gentle blending, can produce very detailed and vibrant work.

Rowing

Created using acrylic in fine washes, which were added layer by layer. There are no features on the figures. Detail would detract from the main interest which is the rowing action.

Demonstrations
Transferring the image

Tracing off

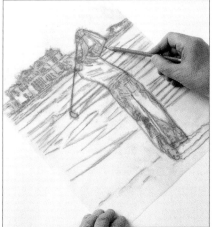

1 Trace your image from the original source. I made this photograph from a snapshot I took of an amateur golfer in a public park. I asked his permission, and he was happy to pose for me. I superimposed his image on to a photograph I took of the famous golf course at St Andrew's.

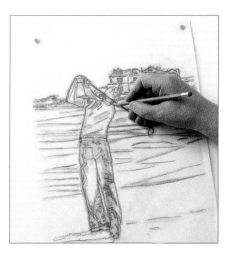

2 Turn the tracing face down and use an HB pencil to go over the lines on the back, covering them with graphite.

3 Attach the tracing, face up, to watercolour paper using adhesive putty. Go over the lines on the front, again using the HB pencil.

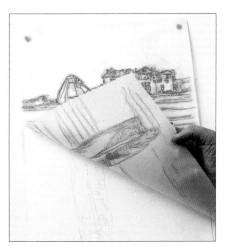

4 Lift the tracing as you work to reveal the image appearing underneath.

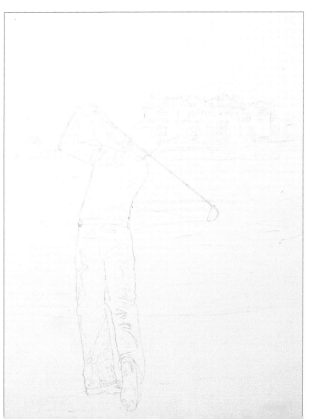

The image, ready for painting.

Squaring off

Another way to transfer your drawing to the final support to be painted is to use a simple grid system which has been used for centuries by artists. This technique, known as squaring off, can also be used to enlarge or reduce your drawing.

1 The initial stage is to draw a grid over your photograph or drawing. In order to avoid having to continually draw too many grids, I suggest that you draw a grid on a piece of clear acetate or tracing paper. This allows you to store the grid and use it again whenever needed. In this case I have placed a grid over a cartoon illustration of an angry football.

2 Draw a similar grid on your final support. If you want to enlarge your drawing then enlarge the grid on the support. For example, if you have 2.5cm (1in) squares on your original grid and you decide to put 5cm (2in) squares on your final grid, the drawing will be four times larger than the original. Draw your grid very lightly as you will erase it when your drawing is complete. The grid in the photograph has been darkened for clarity. Start drawing the outline of the details in each box by copying from the original grid.

3 Keep copying the details from the squares in the original grid on to your new grid until the drawing is complete.

4 Erase the grid, taking great care not to remove your drawing. It is also important not to damage the surface of your paper or canvas during the erasing process. Once this is completed, you should have a fairly accurate representation of your original illustration or photograph. Although I used a simple cartoon in my example, it required the drawing of a circular ball, which can be very difficult to do accurately freehand.

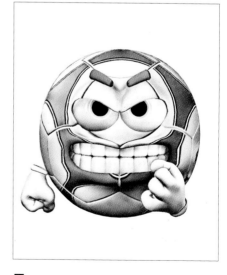

5 You are now able to continue to progress the final artwork. In this instance I made a fairly detailed pencil drawing.

Skateboarder

In this demonstration we will portray a skateboarder in mid-air action and use a mask to aid in the creation of the spattered background.

You will need

Hot-pressed watercolour paper, 40.7 x 30.5cm (16 x 12in)

Tracing paper

Acrylic paints: yellow, green, red, blue, flesh tint, yellow ochre, dark brown, ultramarine, Payne's gray, black

Acrylic inks: brown, Payne's gray, my flesh mix (fifty drops of yellow, thirty of red, five of blue and twenty of black)

Brushes: no. 16 bristle, no. 4 sable, no. 1 sable

Coloured pencils: light green, terracotta, white, burnt umber, dark brown

Scalpel and cutting mat

Kitchen paper

Adhesive putty

Old toothbrush

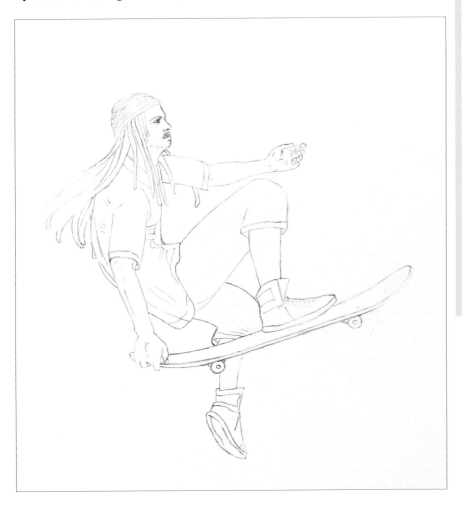

1 Trace the image from the finished painting on page 79, then transfer it on to watercolour paper as shown on page 68.

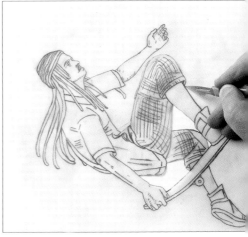

2 Place the tracing on a cutting mat and use a scalpel to cut very carefully around the edges to create a mask.

3 Attach the tracing to the image using adhesive putty, so that the figure and skateboard are covered. Dip an old toothbrush in yellow acrylic paint and flick the bristles so that paint spatters over the edges of the mask. Allow to dry.

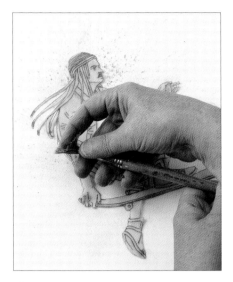

4 Take a no. 16 bristle brush, dip it in green acrylic paint and spatter this all over the painting. Allow to dry.

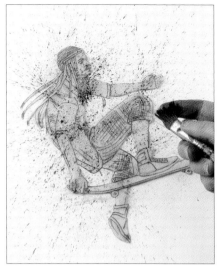

5 Repeat with red acrylic paint and allow to dry.

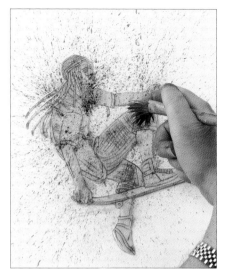

6 Spatter blue paint over the painting in the same way and allow to dry.

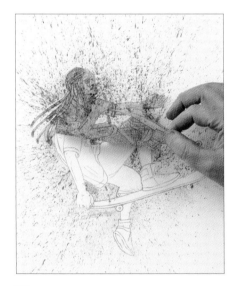

7 Pull off the tracing paper mask to reveal the drawing.

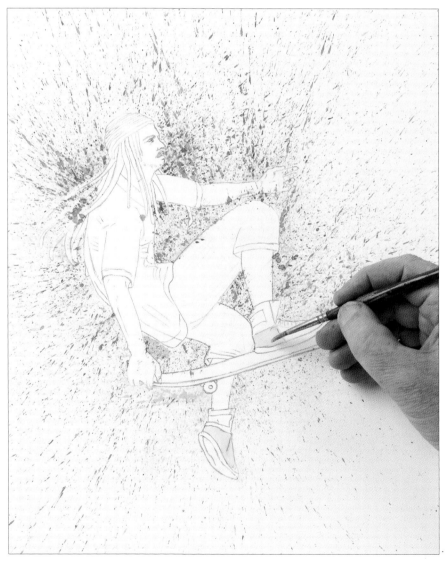

8 Take a no. 4 sable brush and use the yellow acrylic paint to paint part of the shoes.

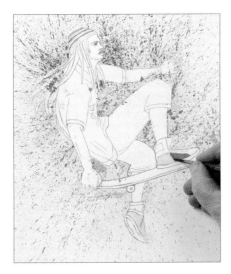

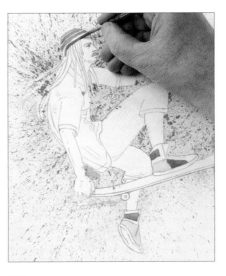

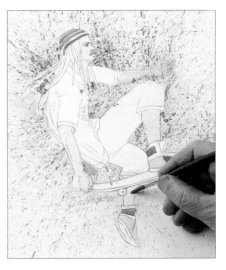

9 Paint red acrylic paint on the bands of the hat and on part of the shoes.

10 Change to green acrylic paint and add more bands to the hat and sections to the shoes.

11 Use watered down flesh tint acrylic paint as a base for the skater's skin wherever it is showing. Blot it dry with kitchen paper and layer more paint on top.

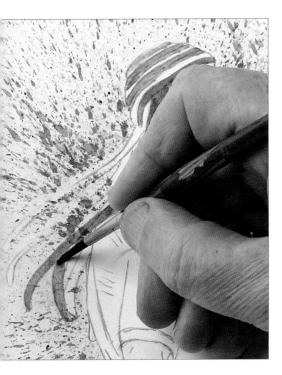

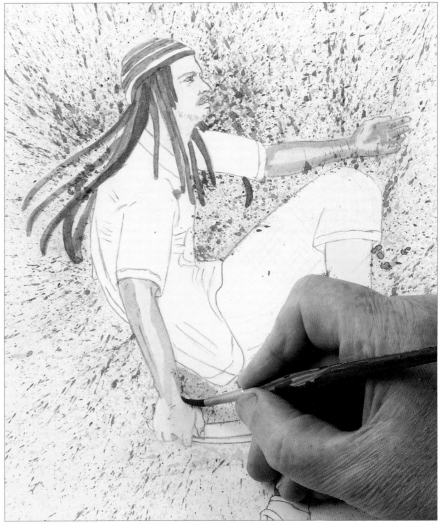

12 Mix brown and Payne's gray acrylic ink and paint the dreadlocks. Blot to dry and paint another layer.

13 Make a weaker mix of the same colours and paint the shaded parts of the flesh tones.

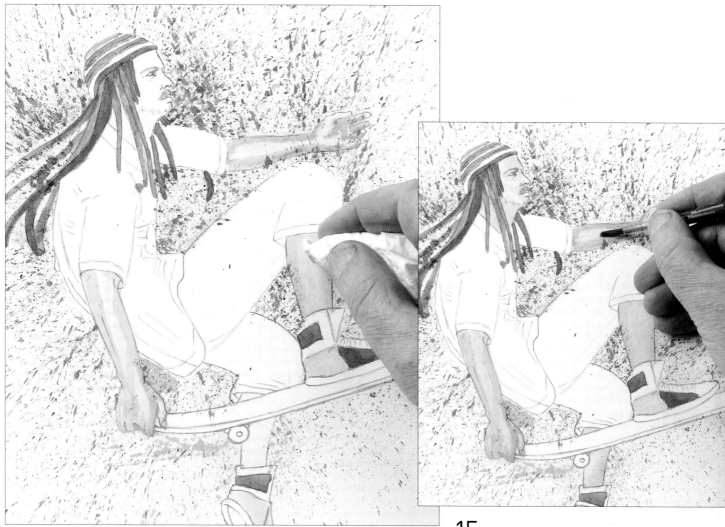

14 Continue painting the darker tone on the arms and legs. Blot with kitchen paper to dry, then add further layers.

15 Make a dilute mix of yellow ochre acrylic paint and paint this over the skin tones.

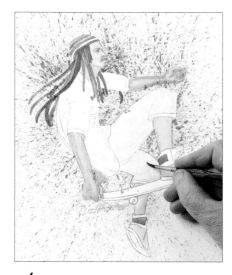

16 Water down Payne's gray acrylic ink and paint it on the clothes.

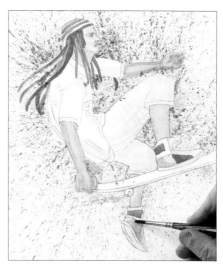

17 Reinforce the yellow on the shoes with yellow ochre acrylic paint.

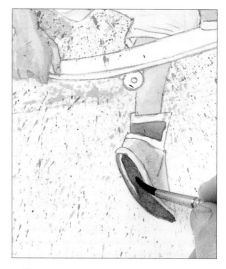

18 Apply Payne's gray acrylic paint to the sole of the shoe.

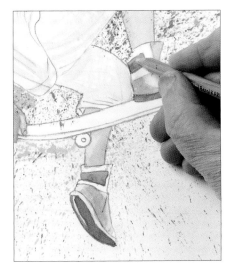

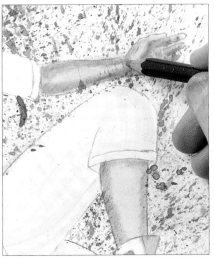

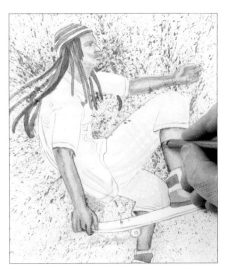

19 Use light green coloured pencil to add detail to the shoes.

20 Shade the flesh areas with terracotta coloured pencil.

21 When you have used the terracotta pencil on all the flesh areas, change to the darker burnt umber to shade the edges.

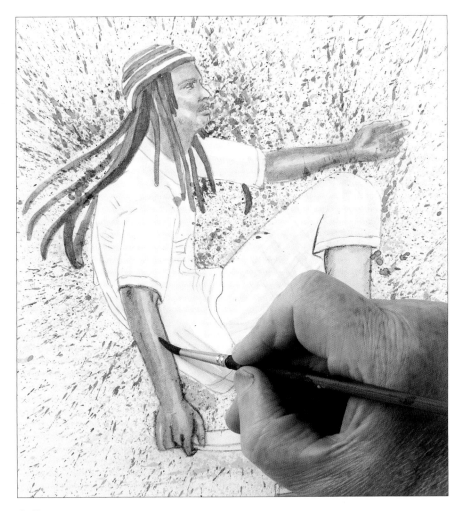

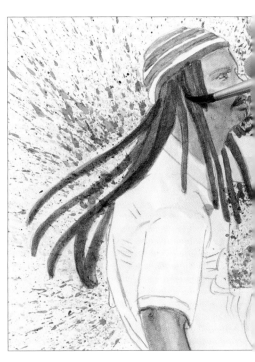

22 Use acrylic ink in my flesh mix (fifty drops of yellow, thirty of red, five of blue and twenty of black) with the no. 4 brush to paint the flesh areas. If you prefer, use a ready-made flesh colour. Blot with kitchen paper and build up layers as before.

23 Paint the dreadlocks and moustache with dark brown acrylic paint.

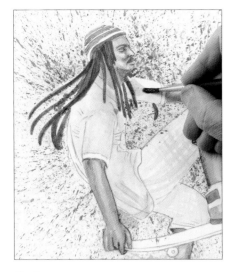

24 Paint a thin wash of ultramarine acrylic paint over the shirt.

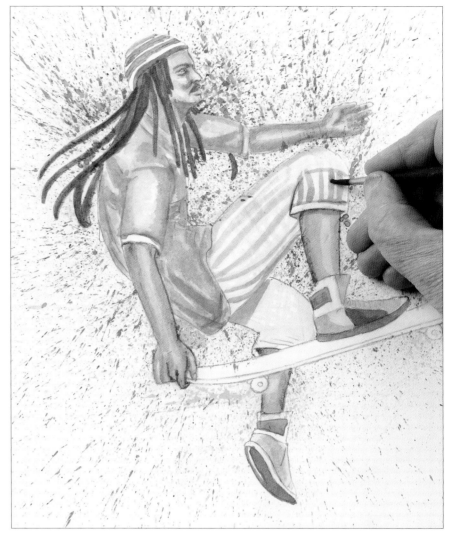

25 Darken the shirt and add shade with Payne's gray acrylic paint, then use the same to paint stripes on the trousers. Blot to dry, then continue adding layers and paint checks.

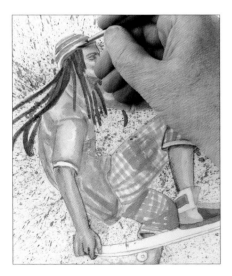

26 Reinforce the green of the hat with acrylic paint, then the yellow, using the no. 1 sable.

27 Water down black acrylic paint and paint the dark details on the shoe.

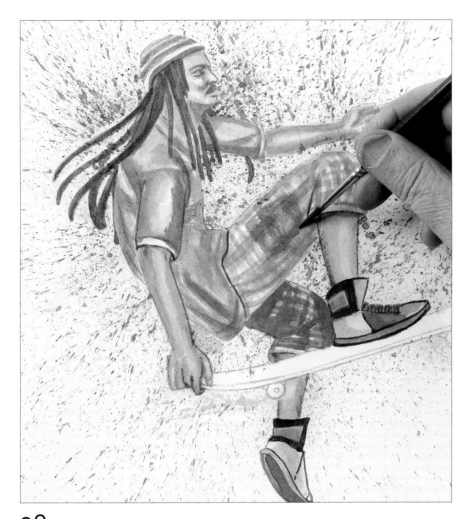

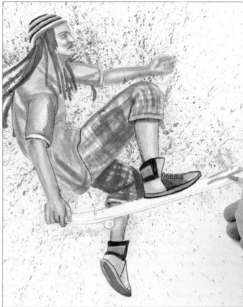

29 Reinforce the red in the hat and the shoe with acrylic paint. Paint parts of the skateboard with yellow acrylic paint, then add red to make orange, and suggest a design.

28 Continue painting dark details on the shoes, then use Payne's gray acrylic paint on the trousers.

30 Use watered down black acrylic paint to paint some of the darker details.

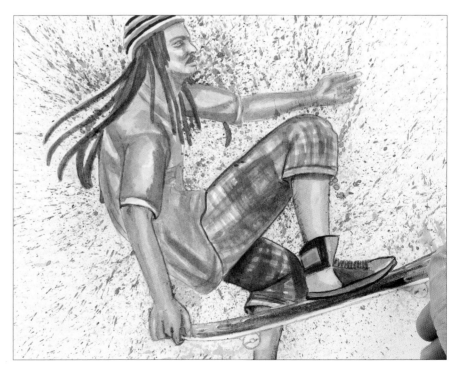

31 Use burnt umber coloured pencil to draw in the details of the face, then change to terracotta and continue adding tone.

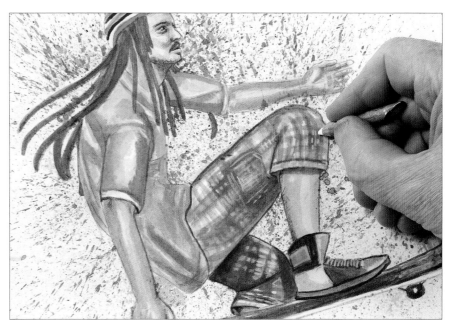

32 Draw highlights and details on the clothes using white pencil.

33 Use dark brown coloured pencil to develop the texture of the dreadlocks.

34 Use the no. 1 brush to paint yellow ochre acrylic paint on the side of the skateboard.

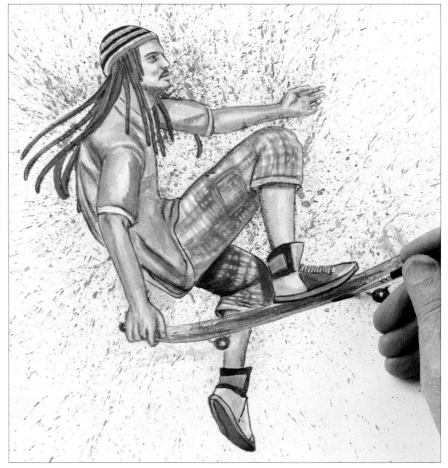

35 Paint a design on the t-shirt with red acrylic paint, then blot with kitchen paper to dry.

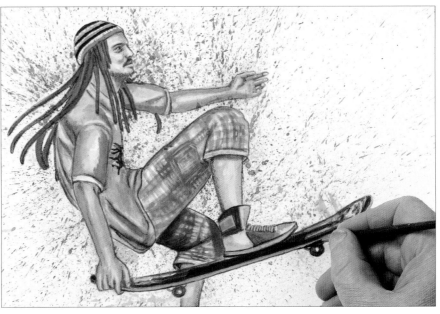

36 Add more white pencil highlights, then use dilute black acrylic paint on the no. 1 brush to paint dark details on the shoe and skateboard.

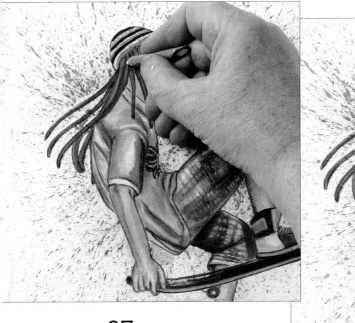

37 Continue painting details in this way. Calm down the red design on the shirt with burnt umber and white pencil, then use white pencil to add highlights. Use the no. 4 brush and brown acrylic ink to further reinforce and shade the flesh areas.

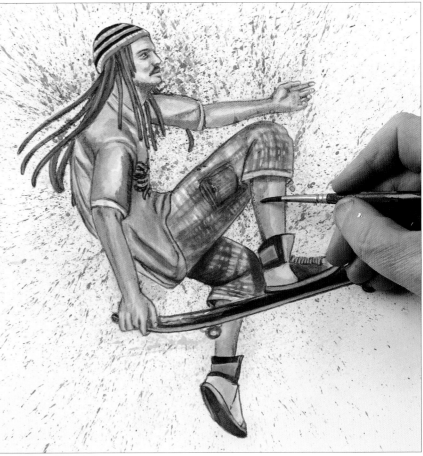

Opposite
The finished painting.

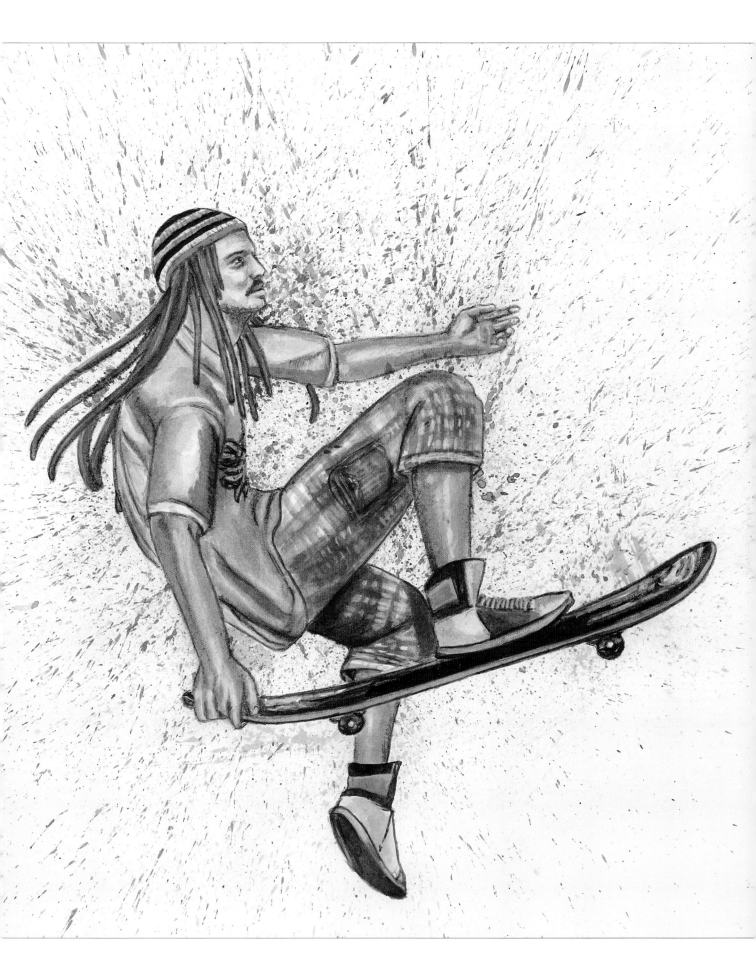

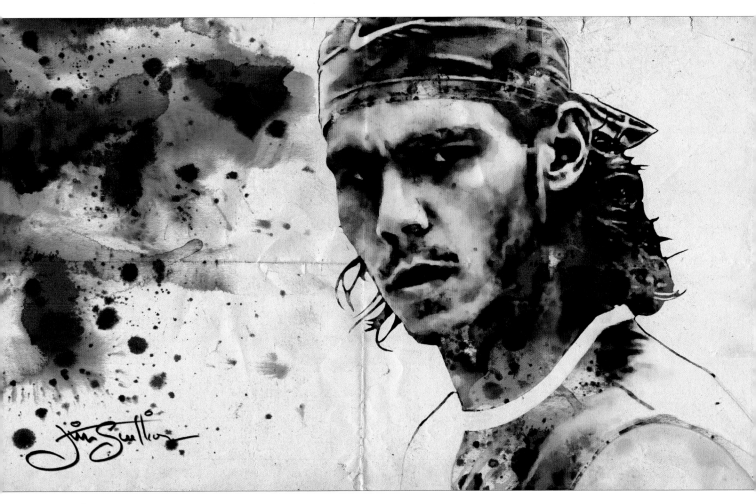

Rafa

This painting of Rafael Nadal was created in a similar way to the Skateboarder in that a mask was used. In this instance a sheet of low-tack masking film was placed over a light outline drawing of the tennis star. The low-tack adhesive sticks the film to the paper firmly without damaging the surface. The negative shapes in the face were then cut from the mask using a scalpel, taking great care to cut only the masking film and not the paper surface. When this was completed, the paper was lightly dampened and acrylic ink droplets were dropped on to the surface within the masked area where the different colours of ink mixed with each other. This was allowed to dry completely and then further acrylic colours were lightly spattered across the area. When totally dry, the masking film was carefully removed. More droplets of colour were dropped and spattered on to the left-hand side of the painting and allowed to mix. Although acrylic inks were used in this painting, watercolour could also have been used to good effect.

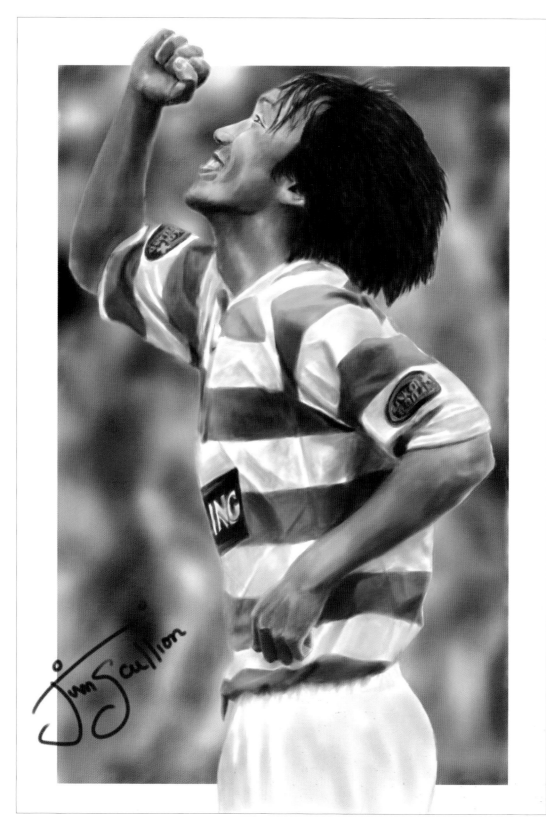

Nakamura

This portrait of Japanese footballer Shunsuke Nakamura is painted in pastel. It shows how a simple mask can help add dimension to the painting. The background area was masked off with low-tack masking tape before being painted. The background was created first and fixed before removing the masking tape. This gave the reduced background nice clean lines. When completed, the figure seemed more three-dimensional, as he was clearly in front of the background.

Golfer

This is purely a fantasy painting of a local man playing golf in his denims, but believing he is really playing at **St Andrews**. I added the golf course from a photograph I had taken there myself. **When painting this, you could try to substitute yourself or someone close to you, to make the painting more personal.**

You will need

Not watercolour paper, 40.7 x 30.5cm (16 x 12in)

Acrylic inks: my flesh mix (fifty drops of yellow, thirty of red, five of blue and twenty of black), yellow ochre, Payne's gray, sap green, earth brown, emerald green, Van Dyke brown, raw umber, yellow

Acrylic paints: ultramarine, light green, emerald green, Payne's gray

Watercolours: blue-green, Van Dyke brown, Payne's gray

Gouache: white, green, lemon yellow

Brushes: no. 1, no. 4, no. 7 sable, 19mm (¾in) flat synthetic, no. 16 bristle

Coloured pencils: copper beech, blue-violet, burnt umber, white, sienna

Kitchen paper

1 Transfer the image on to your watercolour paper as shown on page 68. You can trace it from the finished painting on page 89.

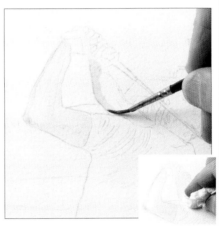

2 I use a flesh mix acrylic ink made from fifty drops of yellow, thirty of red, five of blue and twenty of black. You can mix this or use a ready-made flesh colour. Water it down and apply it to the arms and the side of the face with a no. 1 sable brush. Blot the ink with kitchen paper before it dries, then repeat, building up layers of ink.

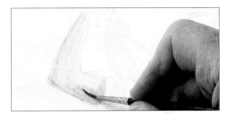

3 Continue in this way, adding layer upon layer. Begin to add tone where the flesh is shaded.

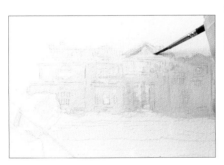

4 Block in the clubhouse with yellow ochre acrylic ink watered down. Leave some areas white. Add a little flesh mix to create shading.

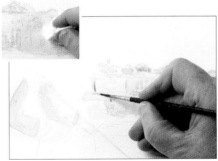

5 Blot the wet clubhouse ink with kitchen paper to lift out colour, creating texture. Continue suggesting detail with the slightly darker mix.

6 Use the no. 4 brush and diluted Payne's gray acrylic ink to paint the areas of shading on the golfer's jeans. Build the colour up in layers as before.

7 Paint clean water in the foreground around the figure, using a no. 7 sable, then drop in sap green acrylic ink. This will only spread over the water, not the figure.

8 Paint stronger sap green for the distant hill to the right of the clubhouse, then mix yellow and emerald green acrylic ink and dilute the mix to paint the sunlit grass.

9 Paint the shading on the shirt with dilute Payne's gray acrylic ink, leaving a little of the green mix on the brush to suggest colour picked up from the grass.

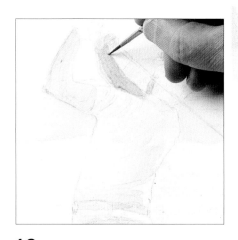

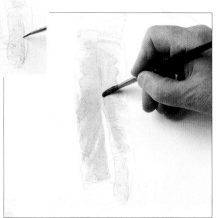

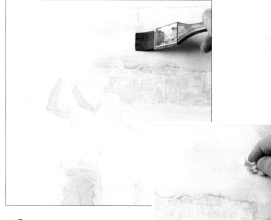

10 Return to the no. 1 sable brush and a stronger mix of the flesh colour and continue layering, adding shade and blotting with kitchen paper.

11 Paint the sole of the shoe with dilute Payne's gray acrylic ink, then change to the no. 7 sable and use diluted ultramarine acrylic paint to block in the jeans colour over the acrylic inks. Allow to dry.

12 Paint the same colour in the right-hand side of the sky, then add water and sweep the blue across the whole sky using a 19mm (¾in) flat brush. Use the no. 7 brush to paint neatly round the figure. Blot the sky while wet with kitchen paper to suggest clouds.

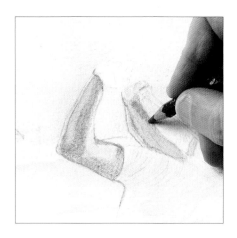

13 Use copper beech coloured pencil to add shading to the arms and hands.

14 Use the flesh mix acrylic ink and the no. 4 sable brush to paint over the arms and hands, then use the same mix on the golf club.

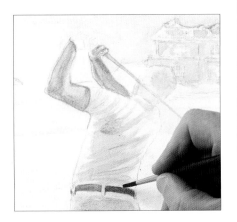

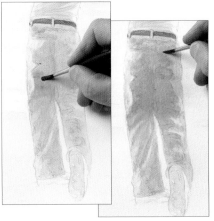

15 Use diluted Payne's gray acrylic ink to paint the glove and the head and to build up the folds in the shirt. Continue painting and blotting the shirt, building up layers of ink. Paint the belt with darker Payne's gray.

16 Continue adding tone to the jeans with the no. 7 sable brush and ultramarine acrylic paint. Build it up in layers as before.

17 Reinforce the tone on the sole of the shoe with more Payne's gray acrylic ink. Shade the arms again with copper beech pencil, then layer more flesh-coloured acrylic ink on top.

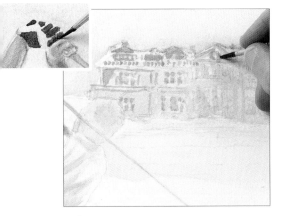

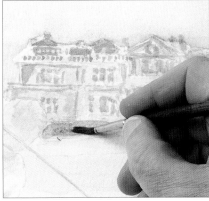

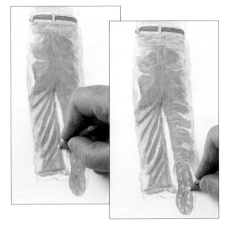

18 Use the no. 1 sable brush and strong Payne's gray acrylic ink to paint the detail on the golfer's glove. Mix flesh colour with the Payne's gray and use the no. 4 brush to paint architectural details on the building.

19 Paint sap green acrylic ink in front of the building with the no. 7 sable brush.

20 Use white pencil to add highlights to the jeans. This will create a resist that subsequent paint layers will not cover. Add the detail of the pockets and the studs on the sole of the shoe.

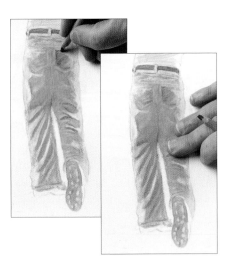

21 Use blue-violet coloured pencil lightly on the jeans, then rub hard with your fingers. This will blend the colour and work with the surface of the paper to create the look of denim.

22 Paint ultramarine acrylic paint over the drawing with a no. 4 brush. Blot the paint and as it dries, the pencil will be visible again. It is important to use good paper for these layering and blotting techniques, as lower quality paper would disintegrate.

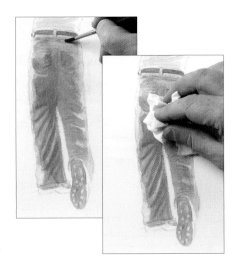

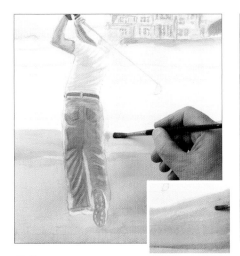

23 Use the no. 7 sable and sap green acrylic ink to reinforce the colour of the grass in the foreground, then use watered down emerald green acrylic ink in the middle ground. Add Payne's gray acrylic ink to darken the grass in places.

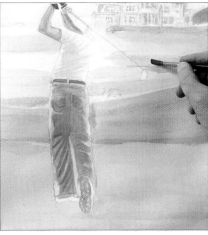

24 Paint the distant, sunlit grass with emerald green mixed with yellow ochre acrylic ink, then paint a band of Payne's gray on either side of the figure.

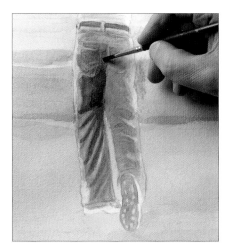

25 Change to the no. 4 sable and paint Payne's gray acrylic ink on the jeans to darken the shaded parts.

26 Darken the folds on the shirt with the no. 1 brush and Payne's gray acrylic ink.

27 Add some detail to the arms with burnt umber coloured pencil, then go over the flesh tones with earth brown acrylic ink. Blot and layer as before.

28 Reinforce the green on either side of the golfer with blue-green watercolour on the no. 7 brush, then while this is wet, drop in Payne's gray acrylic ink. Stipple to create texture.

29 Paint emerald green acrylic ink in the foreground, then change to the no. 16 bristle brush and stipple on undiluted sap green acrylic ink to create the texture of rougher grass.

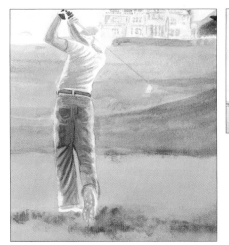

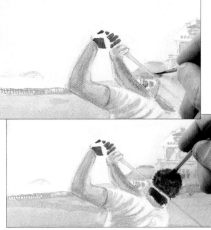

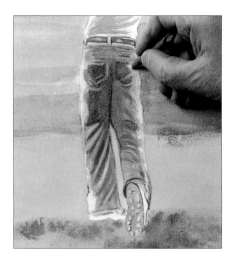

30 Continue building up the greens with emerald green and sap green acrylic inks, using the no. 7 brush. Mix light green and sap green acrylic inks and work on the distant hill and the distance behind the figure.

31 Use the no. 1 brush and a mix of sap green and Payne's gray inks to paint the distant fence and other details. Use the no. 4 sable and Van Dyke brown acrylic ink for the hair.

32 Work on the dark detail of the jeans with burnt umber coloured pencil, then add highlights to the jeans and shoes with white pencil.

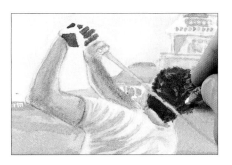

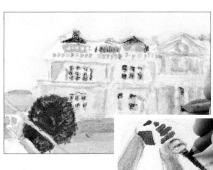

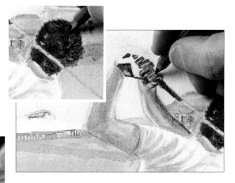

33 Draw highlights on the shirt in the same way, then on the arms. Add tiny highlights in the hair.

34 Add white highlights to the clubhouse in the same way, then use the burnt umber pencil to pick out detail. Used lightly, this works with the paper to create texture. Shade the golf club with the same pencil.

35 Use the burnt umber pencil to add detail to the hair. Add white highlights to the arms and shirt with the white pencil, then return to the burnt umber pencil to work on shading. Add fine detail to the hand with the white and burnt umber pencils.

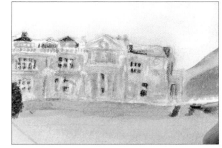

36 Use the no. 1 sable and raw umber acrylic ink on the arm.

37 Use the flesh mix acrylic ink to paint further detail on the clubhouse and in the distance.

38 Paint the sea with ultramarine acrylic paint. Blot with kitchen paper then paint the distant hut with flesh mix acrylic ink.

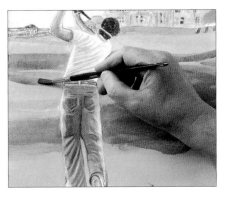

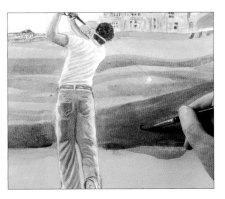

39 Paint blue-green watercolour on the grass to the right of the figure with the no. 7 brush, then drop in Payne's gray acrylic ink wet into wet. Lift out texture with kitchen paper.

40 Continue painting bands of darker grass on either side of the golfer with blue-green watercolour and Payne's gray acrylic ink.

41 Paint sap green acrylic ink over the widest blue-green band.

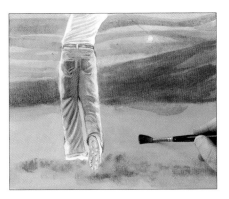

42 Paint a mix of emerald green and yellow acrylic inks in the foreground.

43 Draw highlights on the clubhouse with white pencil, then use sienna pencil to add detail. Blend the pencil with your fingers.

44 Reinforce the white pencil on the clubhouse again, then paint dark details with the no. 4 sable brush and Van Dyke brown watercolour.

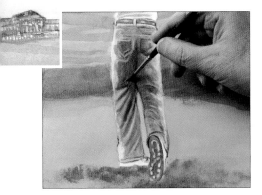

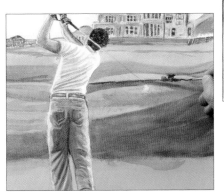

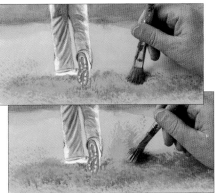

45 Use Payne's gray acrylic ink to add detail to the distant hut on the putting green, and to the shoes and jeans.

46 Paint blue-green watercolour in front of the club-house, then add detail with Payne's gray watercolour. Use the no. 1 brush and a mix of Payne's gray and Van Dyke brown watercolour to paint detail including the little stone bridge.

47 Mix light green and emerald green acrylic paints and use the no. 16 bristle brush to stipple foreground grass texture. Add white gouache and continue stippling, then add ultramarine acrylic paint and suggest dirt flying up as the ball is hit.

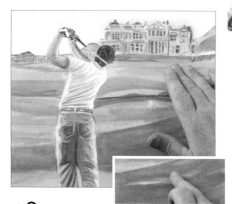
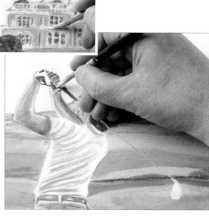
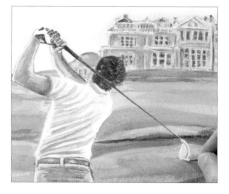
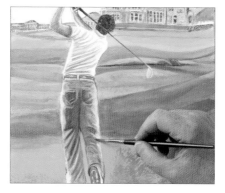

48 Add touches of the same green and white gouache mix to other parts of the green with the no. 7 brush, and blend them in with your fingers. Touch in and blend areas of pure white gouache in the same way.

49 Add white gouache highlights to the clubhouse, the golf club, the shirt and the glove.

50 Use the no. 1 brush to paint Payne's gray acrylic ink on the golf club with a very fine stroke, then mix in white gouache and add detail. Add highlights to the little bridge with the same mix.

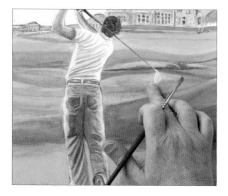
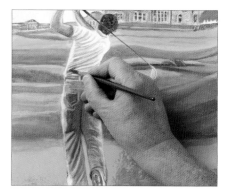

51 Use the no. 7 sable to paint a mix of green and lemon yellow gouache on sunlit areas of the grass. Stipple some areas and blend with your fingers.

52 Paint a tiny bit of the same green on to the jeans leg, the shirt and one arm, to suggest the green reflected there.

53 Add Payne's gray acrylic paint to the mix and paint dark detail on the green. Smooth with your fingers and add some of the same colour in to the folds of the shirt.

54 Reinforce the belt with Payne's gray acrylic paint on the no. 1 brush, and add detail to the distant buildings. Highlight the same buildings with white gouache.

55 Reinforce the highlights on the jeans with white pencil.

Opposite
The finished painting.

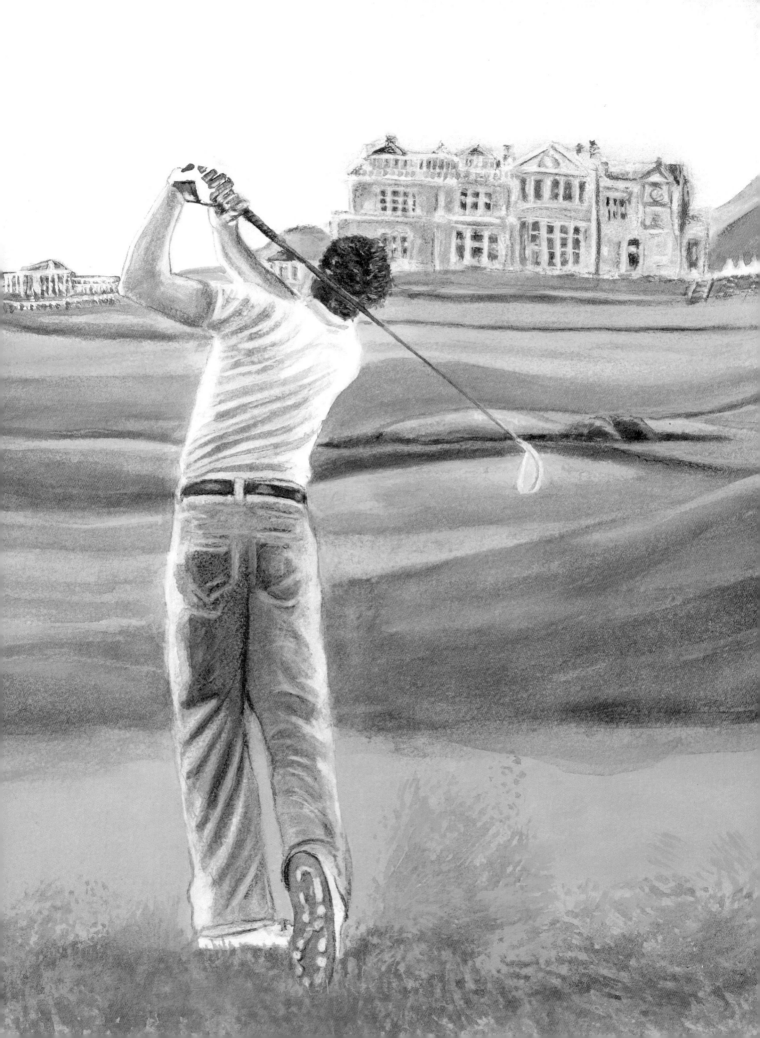

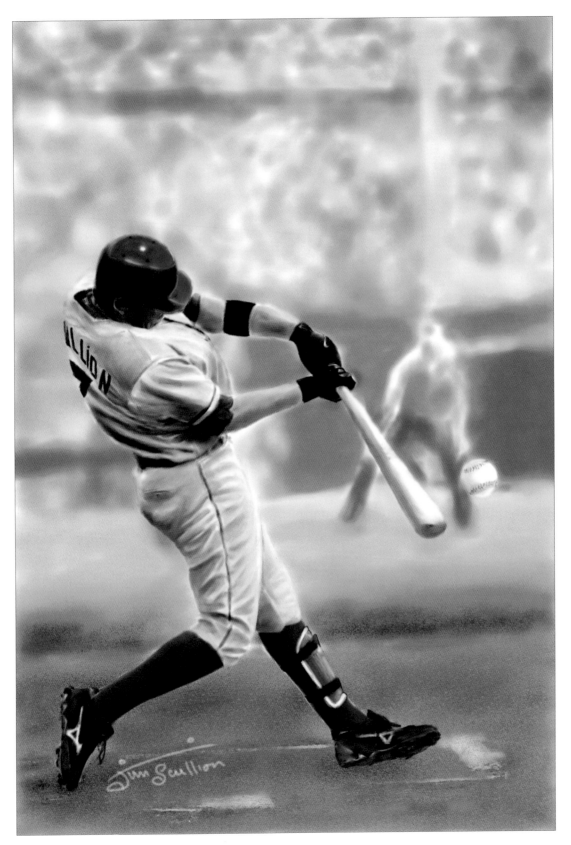

Baseball

Continuing with the fantasy theme, this baseball player created in pastel has been painted with one particular person in mind: myself. I have given him my build, and as he is painted from the side, not too much detail was needed to make him look like me. The name on the back of the uniform helps to finalise the fantasy.

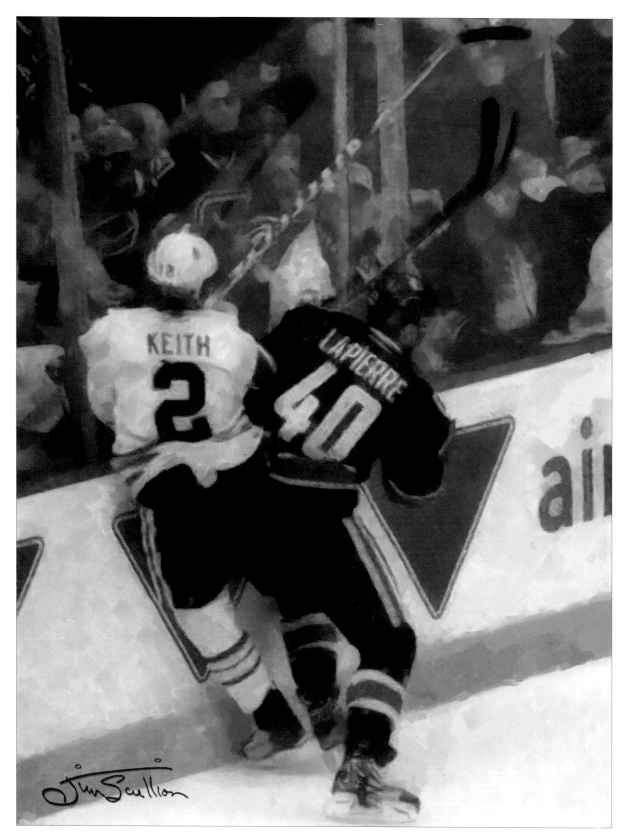

Body Check

This acrylic painting of ice hockey players is not a fantasy portrait but is the type of action shot that can easily be adapted when creating it. The faces of the players are fairly well hidden, so there is no problem regarding recognition. You can change the colour of the uniform to your chosen team and add the name you want on the back. A little adjustment of the hair style and you can create your own fantasy hockey star.

Diver

Throughout my life I have been a great lover of cartoons and animation. I have always loved the scenes where the character runs off a cliff and hovers in mid-air for a few seconds before realising its plight and plummeting to the ground. This painting is probably my homage to those great scenes. I called this painting *Flying Without Wings*. I have frozen the diver in mid-air at the point where he freefalls for a millisecond before he swoops into the final manoeuvre.

You will need

Not watercolour paper, 76 x 51cm (30 x 20in)

Acrylic paints: white, cadmium yellow, burnt umber, cadmium red, alizarin crimson, Prussian blue, burnt sienna, yellow ochre, black, Payne's gray

Synthetic brushes no. 5, no. 8 flat, no.16 bristle and 19mm (¾in) flat

Sable brush no. 7 round

Kitchen paper

Kneadable putty eraser

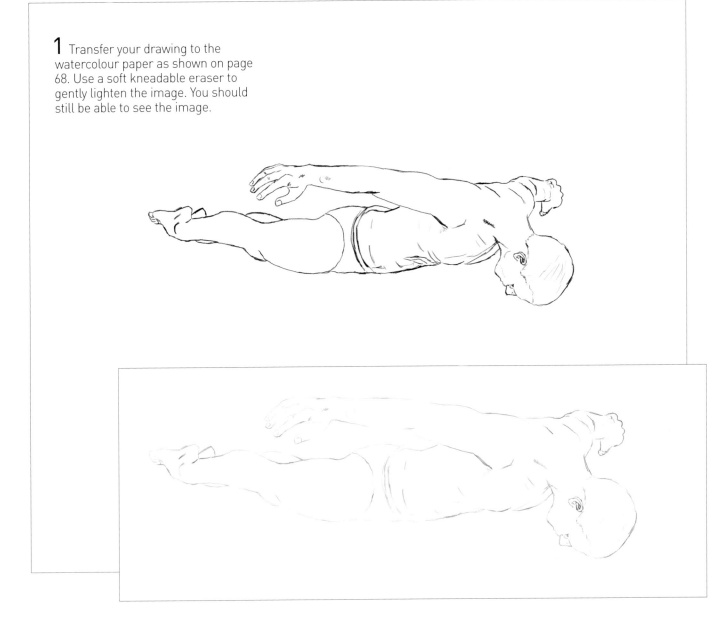

1 Transfer your drawing to the watercolour paper as shown on page 68. Use a soft kneadable eraser to gently lighten the image. You should still be able to see the image.

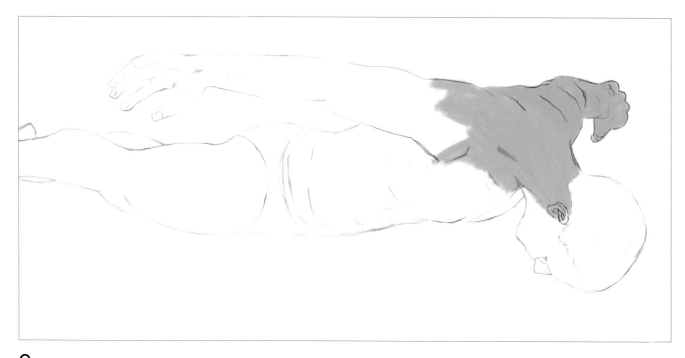

2 Using the sable brush, start to add a mid-tone flesh colour wash to the body. The mid-tone flesh can be created by mixing white and cadmium red with a little touch of cadmium yellow. Start at the neck and follow the contours of the body.

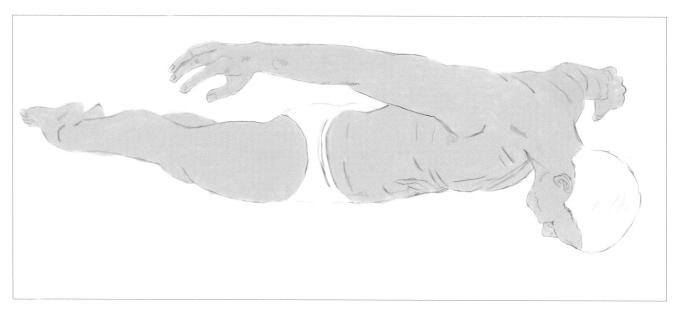

3 Cover the whole body with the mid-tone flesh wash and let it dry.

4 We will now start to add tone and value to the body, using the no. 5 and no. 8 synthetic brushes. Use the no. 5 brush to apply the colour and the no. 8 brush to blend. After each blending application, clean the brush by rinsing in water and drying immediately with a piece of kitchen paper. It is important to work in small areas and to work quickly as the acrylic paint can dry very fast and hamper the blending process. Add a little burnt umber to your original mix to darken the mid-tone; we will call this mix 2 for reference. Add this to the upper neck and shoulder. Then, with a little undiluted burnt umber, paint on to the underside of the diver's left arm and shoulder to add a darker tone.

5 Using the no. 5 brush, add burnt umber to the edge of the hand and around the edge of the neck, chin and roughly around the eye. This is helping us to establish the darker areas of the figure.

6 Continue to add burnt umber around the edge of the face and on the line of the neck. Using mix 2, add some shading to the back of the neck and the underside of the neck. Use a no. 8 flat brush to blend the burnt umber on the neckline with the mix 2 on the neck.

7 Using the no. 5 brush, continue to add flesh tone mix 2 to the face and blend with the darker outlines around the face. This helps to give the face a sense of shape. Also add the hair using a little of mix 2 and gradually build it up by adding and blending burnt umber into the surface of the hair. Lightly blend the dark areas around the edges of the hand on to the hand itself.

8 Using the no. 8 brush, blend the hair on to the nape of the neck and add a little burnt sienna to the face, hand and upper chest and blend into the shadows. This adds a little warmth to the painting.

9 Paint a layer of mix 2 on to the hand and arm and blend it in, then add some burnt sienna to the area to add warmth and blend this also. When blending, it is important to continually wash your blending brushes in water and dry them with some kitchen paper.

10 Add more mix 2 to the upper chest area and the shoulder, then add some burnt umber to the shoulder joint, and a little burnt sienna to the chest area.

11 Now blend this area with a clean no. 8 brush, following the contours of the muscles.

12 Continue down the abdomen, adding mix 2 and then burnt umber and burnt sienna.

13 Blend the abdomen area using a clean no. 8 brush.

14 Using the sable brush, add the swimming shorts with a mix of burnt umber and black. The body is now beginning to take shape.

15 Return to the no. 5 and no. 8 brushes, and continue the same process of adding the colours and blending down the length of the leg. Pay close attention to the shadow of the arm across the upper leg. This helps to add dimension and depth to the painting.

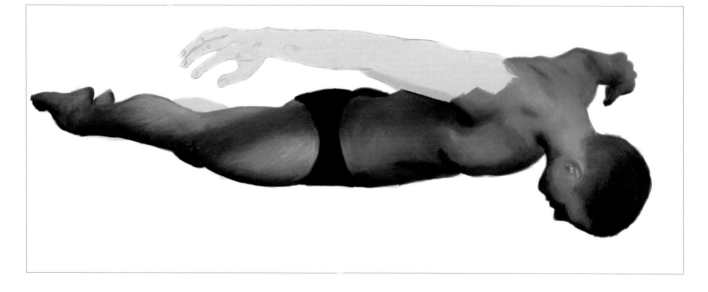

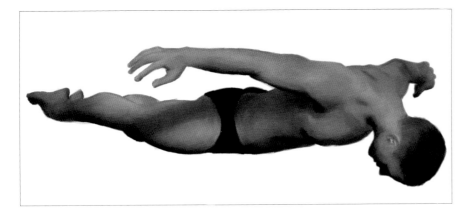

16 Continue the process along the upper arm. Note that the upper arm is not in shadow and therefore has much less darker tonal shading.

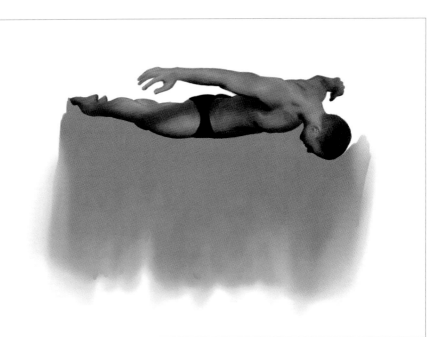

17 Using a mix of Payne's gray and white, create a light grey wash and using the 19mm (¾in) flat brush, paint this under the figure. Blend at the edges with a clean, wet no. 8 brush.

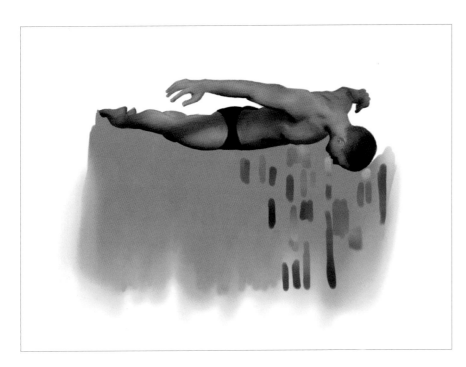

18 Once the background has dried, add short strokes of colour with the no. 5 flat brush. Add flesh colours and blues, greys, greens and yellows mixed from your palette. Don't clean the brush between different colours, as you want to blend these strokes together and a little mixing on the brush will help with that process.

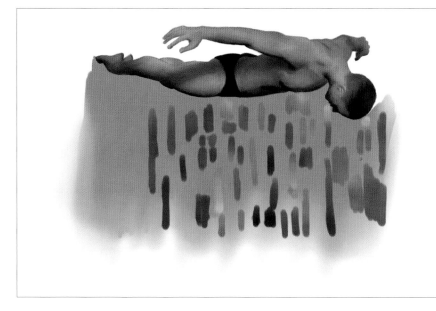

19 Continue adding the colours across the paper.

20 Now using the no. 16 bristle brush, start blending the colour together with vertical strokes.

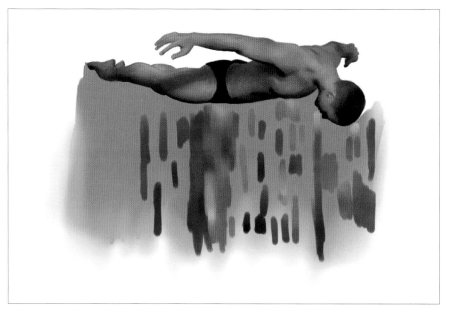

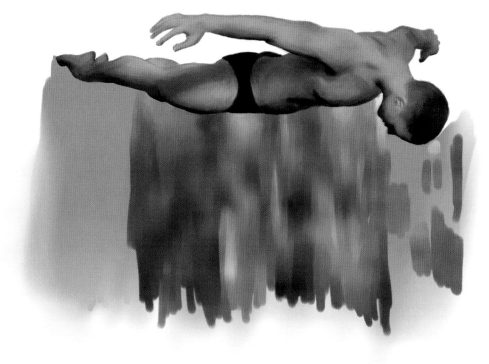

21 Continue this blending motion across the page. If your brush gets too muddy with colour, give it a quick rinse and dry with kitchen paper and continue the blending.

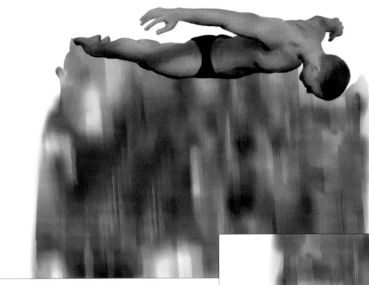

22 Continue adding colour and blending until you have covered the whole of the bottom of the background. When completed, use a wet brush to blend horizontally across some areas. You are trying to create the effect of a crowd in the background that is out of focus and blurred, so that we recognise that the diver, although apparently frozen in mid-air, is actually falling at great speed.

23 Turn your paper upside-down and using your grey mixture, create a wash underneath the figure.

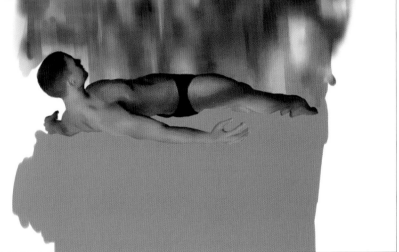

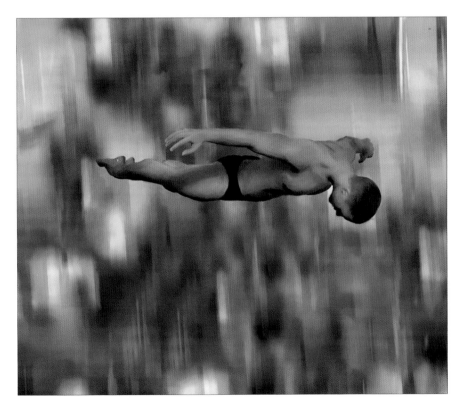

24 Add colour and blend the scene in the same way as before. Return your painting to an upright position and the diver now seems to be plummeting towards the pool. If you are happy with your work so far, add your signature and you are finished.

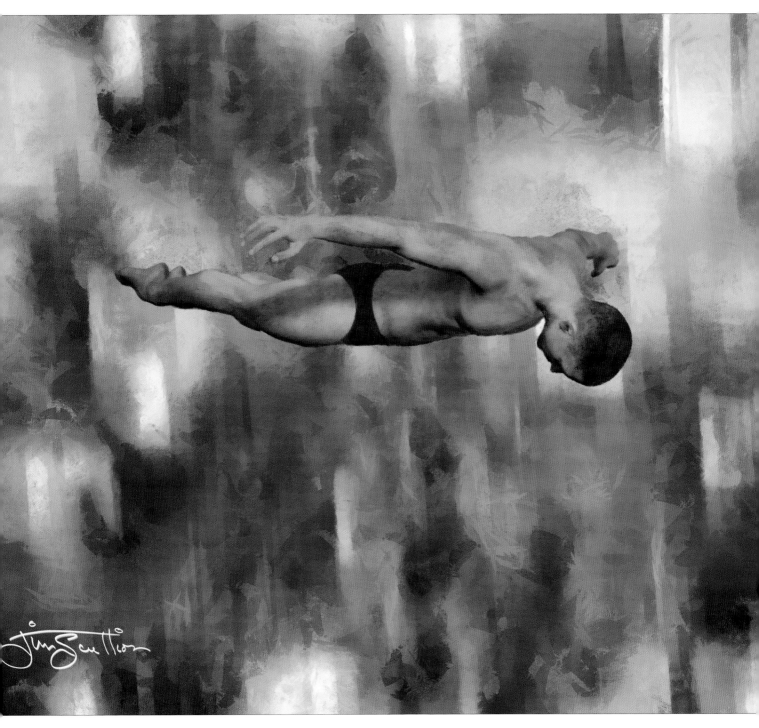

The finished painting

Although I am often happy at this stage in a painting, there are times when I want to add more. Here I added a lot more movement to the painting. I used pastels and pastel pencils to add texture to the painting, using colours from the figure to draw him more into the background. I also used more paint and a degree of scratching and scraping to get my desired effects. If you feel adventurous, have a close look at my final work and go for it.

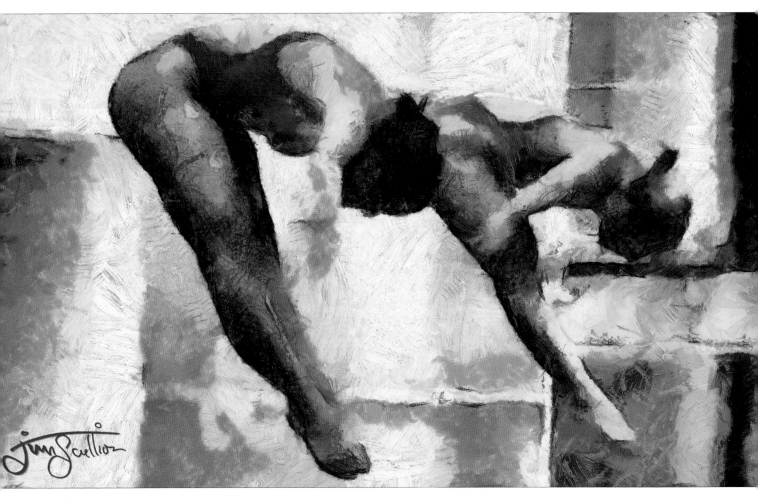

Divers

In this painting I have created a very similar subject but in a completely different way. These are two synchronised divers in the act of diving into a pool. I wanted to create an image which would reflect the movement and the excitement of this sport without getting lost in portraying detail. I feel that if I had portrayed these two divers in detail while frozen in mid-air, the painting would have lacked the energy that I wanted to create. Initially I started by painting a flat background in blue using acrylic. I then sketched in the background using thicker acrylic strokes. I also developed the figures very roughly using basic flesh tones in thick acrylic. Using a knife and dry brushes, I scraped back the varying layers of paint before they dried to give the whole picture texture. Once this had dried, I built up the colour and tone in the background and on the figures using soft and hard pastels. This was done using very short and fine strokes of pastel. Where the pastel had a problem adhering to the surface, I used coloured pencils. The whole painting was then sprayed with an acrylic fixative.

Skier

This painting is in very much the same style as the painting of the diver. Painted using the same materials, it focuses on more horizontal and diagonal blending, as the figure is moving across the picture rather than down. There is no crowd in the background but we are still able to pull muted colours from the surroundings to create the effect desired.

Soccer Players

This painting is of two fictional soccer players. If you prefer, you can change the colours of the strips to your desired teams.

You will need

Hot-Pressed watercolour paper, 76 x 51cm (30 x 20in)

Acrylic paints: white, cadmium yellow, burnt umber, cadmium red, alizarin crimson, Prussian blue, burnt sienna, yellow ochre, black, Payne's gray, emerald green

Brushes: no. 1 sable, no. 4 sable, no. 8 flat synthetic, no. 16 bristle

Coloured pencils: white, light green, light blue, burnt sienna and burnt umber

Tortillons for blending

1 Transfer your image to the watercolour paper using the method described on page 68. You can use this drawing or the finished painting on page 113, and enlarge the image before tracing it.

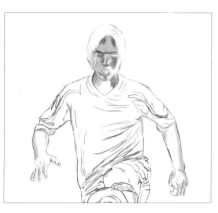

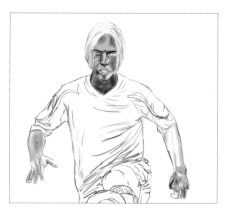

2 Start by adding a mid-tone acrylic paint flesh colour to the left-hand side of the face. This is created using alizarin crimson mixed with white and a little touch of cadmium red. Apply it with the no. 4 sable brush.

3 Add a little of the mid-tone wash to the right-hand side of the forehead, the sides of the neck and the sides of the arms and fingers. Allow this to dry, and using the burnt sienna pencil, add a little colour to the temples, around the eyes, nose, lower mouth and neck. Then blend into the paper using a tortillon.

4 Add some burnt sienna pencil to the arms and hands and, using the burnt umber pencil, add some dark lines around the eyebrows, the side of the mouth and the hand. Using a mixture of alizarin crimson and burnt umber acrylic, create a dark wash and apply it under the chin using the no. 4 sable brush.

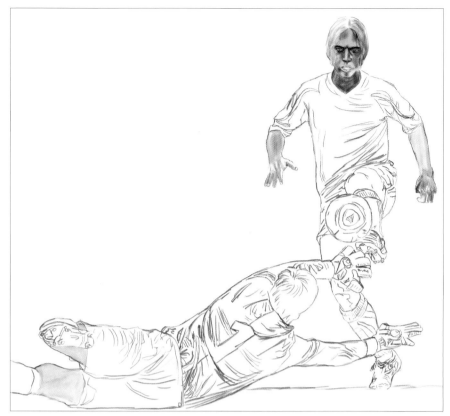

5 Apply the mid-tone flesh colour to the goalkeeper's legs.

6 Using a finely sharpened burnt umber pencil, add detail to the eyes, around the edges of the hair, the nose and the mouth. Using the no. 4 sable brush, paint a little of the dark acrylic wash of alizarin crimson and burnt umber in the body of the hair.

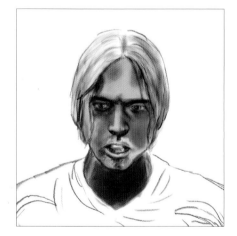

7 Add more dark wash under the chin and blend using a dry no. 8 flat synthetic brush.

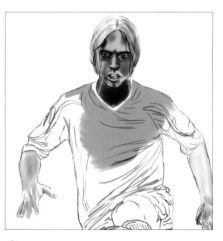

8 Using the no. 4 sable brush, add a light wash of emerald green thinned with water to the shirt.

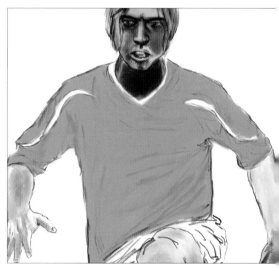

9 Note that this wash will hide most of your original drawing guidelines in the shirt, but you should still be able to see them slightly.

105

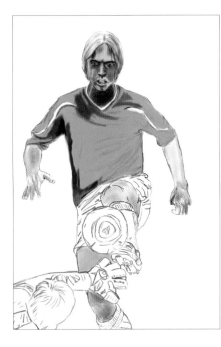

10 Still using the no. 4 sable brush, add light flesh tones to the legs and when dry, add a little burnt sienna pencil and blend in. Add darker tones of emerald green mixed with a little Prussian blue. Add some burnt umber mixed with black underneath the arm.

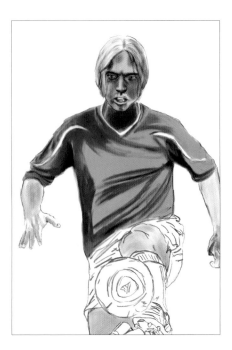

11 Continue adding the darker tones and following the contours of the folds in the shirt from the original drawing.

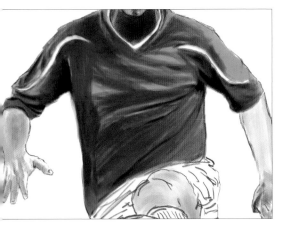

12 As you gradually cover the shirt in darker tones, use the no. 8 flat brush to blend these in and add really dark details into the folds.

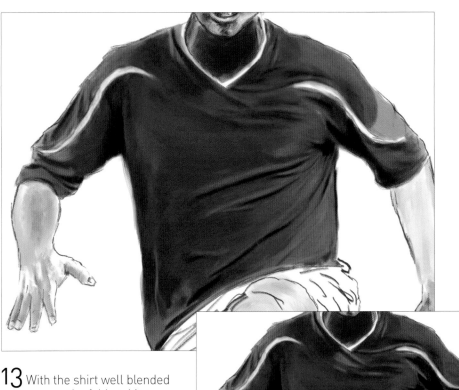

13 With the shirt well blended you can see the folds taking shape. There should be light tones on the highlights of the folds and dark tones in the creases, under the arms and in the folds themselves. Add light green pencil and a little white to the highlights to further emphasise the folds and the movement in the material.

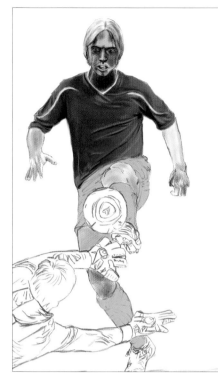

14 Add a light green wash to the shorts and socks.

15 Build up the colours in the shorts the same way as you did in the shirt.

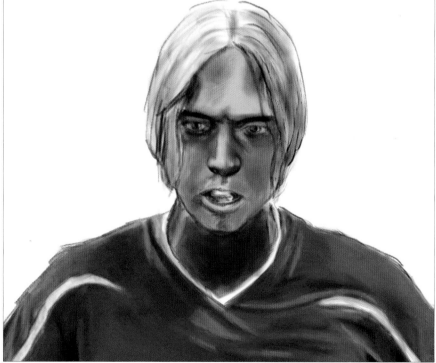

16 Add the dark shadows and the highlights to the shorts.

17 Build up the colour and the shadows and highlights in the socks, in the same way as in the shirt and shorts.

18 Using the no. 4 sable brush, add a wash of light flesh around the face and allow it to dry.

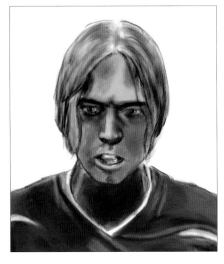

19 Add a little more dark wash of alizarin crimson and burnt umber to the hair and, when this is dry, use the burnt umber pencil to add some detail to the hair and to the strands of hair falling in front of the face.

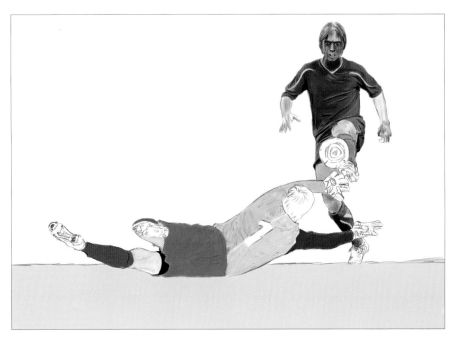

20 Start to work on the goalkeeper's clothing. Using the no. 4 sable brush, add a light wash of blue (Prussian blue thinned with water) to the shorts, socks and right-hand sleeve of the shirt. Add light blue (Prussian blue with a little white and thinned with water) to the left-hand arm and panel of the shirt. On the right-hand panel of the shirt add a pink wash (cadmium red, mixed with a little white and thinned with water). Still using the no. 4 sable brush, add a light wash of emerald green mixed with a little white and thinned with water to the grass area below the goalkeeper.

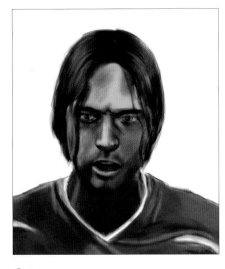

21 While the goalkeeper's clothing dries, add finishing touches to the footballer's face. Using the no. 4 sable and the no. 1 sable for detail, add a little red to the tongue and darken round the beard line with a light wash of Payne's gray and burnt umber. Under the chin, add a little green to this mix to indicate the reflection off the strip and the grass. The hair should also be darkened with this mix, with the darkest towards the bottom on both sides and on the crown of the head at the parting. Sketch burnt umber pencil through the hair to give the impression of strands. Add a little white pencil to the highlights and blend with a tortillon.

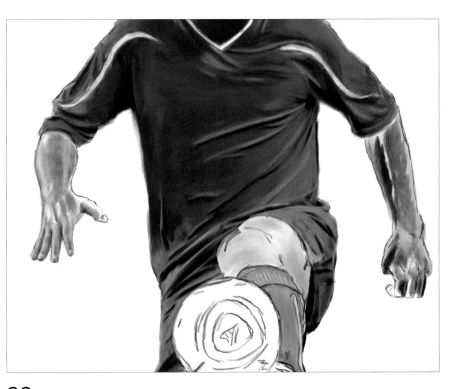

22 Add texture and colour to the arms using burnt sienna pencil, then blend. Add a little burnt umber pencil to the shadows.

23 Continue this process down through to the player's legs.

24 Blend the arms and legs and add highlights using a white pencil.

25 Return to the goalkeeper's clothing and add shadows and folds using darker tones of paint made by adding less water when thinning the mixes. Start with the right arm.

26 Continue adding tones to the shirt and shorts using the acrylic mixes, then add highlights with a white pencil.

27 Create well defined folds and creases on both sides of the shirt, using the same methods as for the attacking player's shirt in step 13.

28 Make the shorts fairly dark by adding Payne's gray to the Prussian blue, but still give them highlights to show the movement of the clothing. Use light blue coloured pencil to help define the highlights.

29 Use a dark wash of burnt umber and alizarin crimson thinned with water in the goalkeeper's hair and add burnt umber pencil strokes to define the pattern and highlight in the hair.

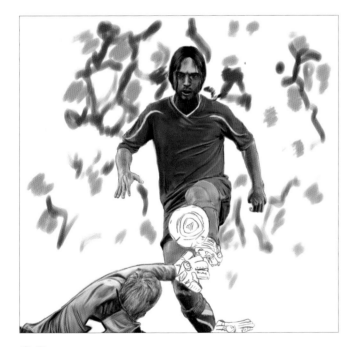

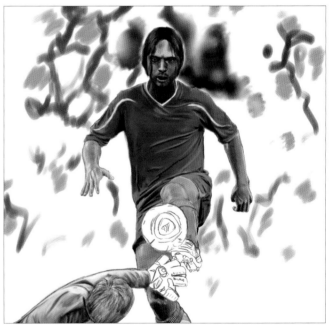

30 It is now time to tackle the background. Add blobs of colour to the background; you need to portray a crowd out of focus, so flesh tones and muted blues, greys, blacks and greens are useful. Use Payne's gray as a shadowy web interlinking the fans.

31 Start blending the colours into each other using the bristle brush with a circular motion.

32 Continue adding colour and blending as you work your way across the painting. Do this in gradual stages as the acrylic can dry very fast.

33 When the crowd is finished, add a darker layer of the grass green, a mix of emerald green, white and a touch of yellow ochre.

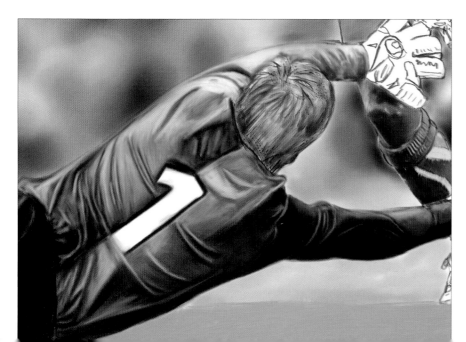

34 Return to the goalkeeper's hair and add gradually darker washes of burnt umber mixed with Payne's gray and a little alizarin crimson. A burnt umber pencil should be used to darken the hair and to give the impression of strands of hair.

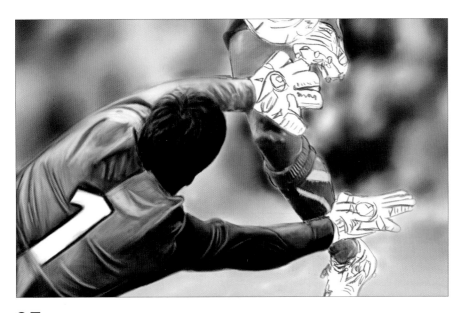

35 To complete the hair, use white acrylic paint applied with the no. 4 sable brush and blend with the no. 8 flat brush to create the highlights, then use burnt umber pencil to create the dark shadows and detail.

36 Add cadmium red to the gloves and an orange made from red and yellow to the boots. Add the rest of the detail with white and burnt umber coloured pencil.

37 Mix a little white with the grass green to create a light green shade and dry brush this roughly on to the grass just below the goalkeeper using the no. 16 bristle brush. Still using this brush, add a stroke of white to the surface to hint at the pitch markings.

The finished painting

The background resembles an out of focus crowd and helps to give the painting dimension and depth. The detail of the clothing also adds to this effect. Two imaginary figures can be made to look fairly realistic.

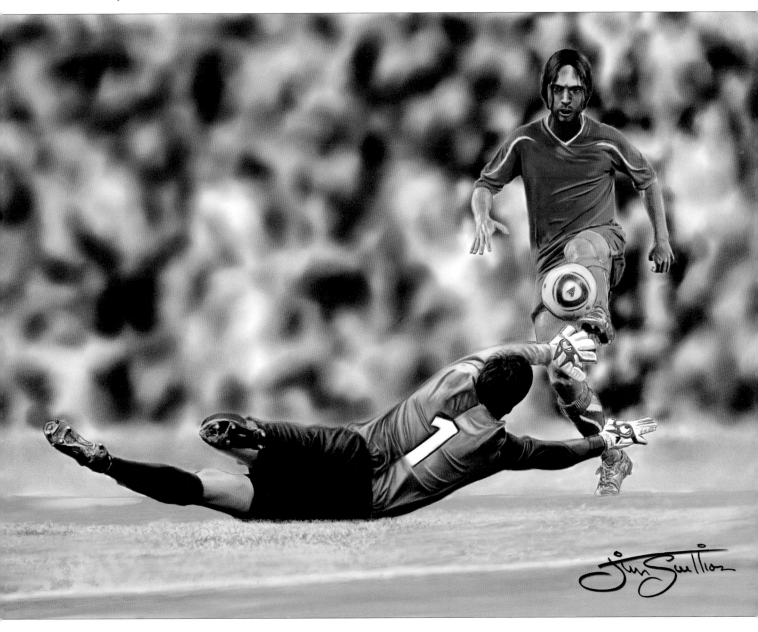

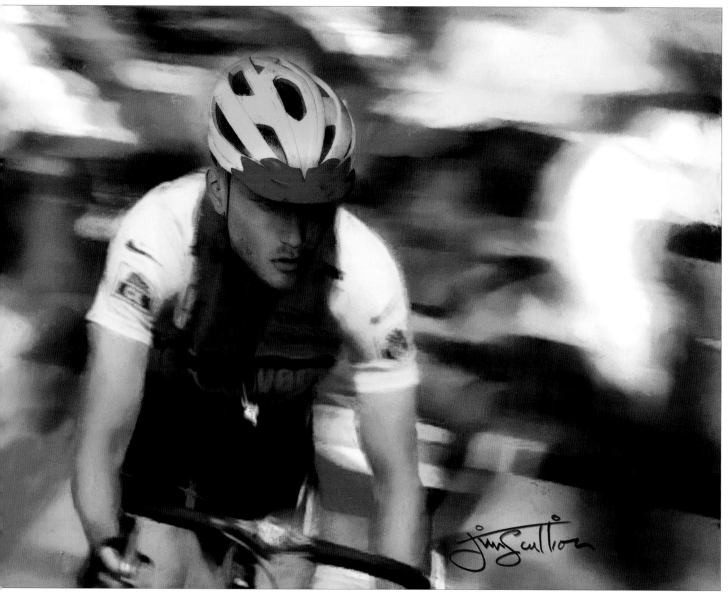

The Tour

This painting of the Tour de France was painted in acrylic on canvas board. It is another example of a painting of a fictional athlete. Again, the background is blended but on this occasion it is done to help create the effect of speed and motion.

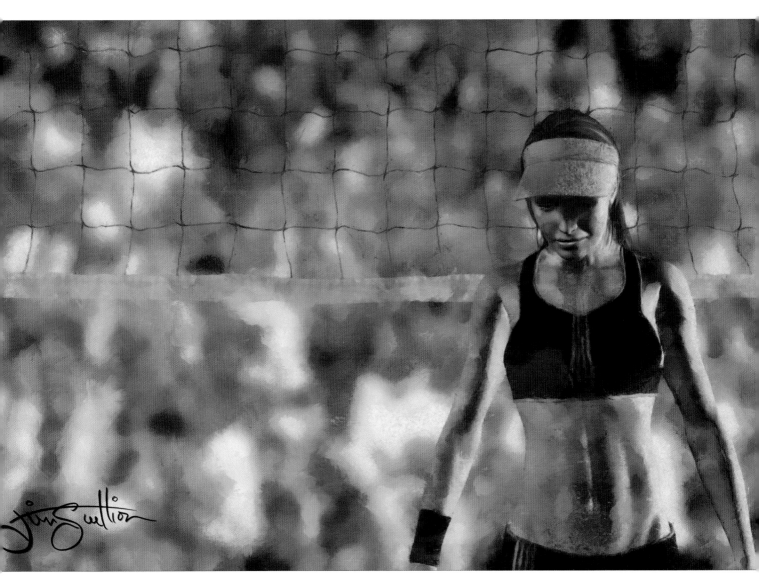

Look Down

Painted in mixed media, this painting depicts a beach volleyball player walking back from the net in a pensive mood. This is not based on a real player. The blended background and the more detailed net help give a sense of depth to the painting. The colours and the shading indicate that the game is taking place in warm conditions.

Athlete

A Jamaican athlete powers towards the finishing line. Her lungs are pumping away like a steam engine as she drives herself to her ultimate goal. We attempt to capture the power and excitement of this scene in this painting.

You will need

Not watercolour paper, 76 x 51cm (30 x 20in)

Acrylic paints: white, cadmium yellow, burnt umber, cadmium red, alizarin crimson, Prussian blue, burnt sienna, yellow ochre, black, Payne's gray, emerald green

Brushes: no. 1 sable, no. 4 sable, no. 8 flat synthetic, no. 16 bristle

Soft pastels: red, blue, white, dark blue, brown

Tortillons for blending

Spray fixative

1 Enlarge this drawing using a photocopier or scanner and computer, and transfer it on to the watercolour paper as shown on page 68.

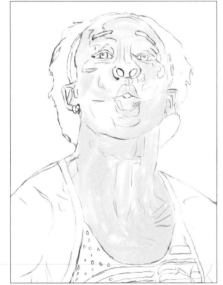

2 Mix up a flesh mid-tone using cadmium red mixed with white, and add a little cadmium yellow and a little burnt sienna. Apply this wash lightly to the face, neck and upper chest using the no. 4 sable brush.

3 Paint the arms with the flesh mid-tone. Add a light wash of cadmium yellow to the vest taking care to leave the space for the green stripes clear.

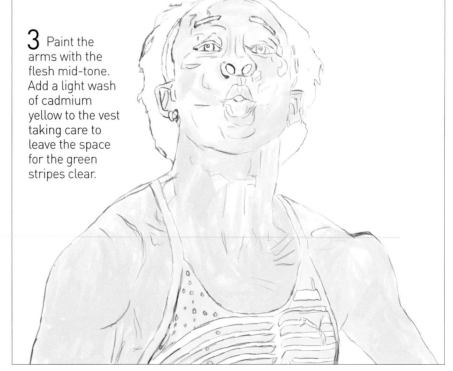

4 Add a light Payne's gray wash to the hair with the no. 4 sable brush.

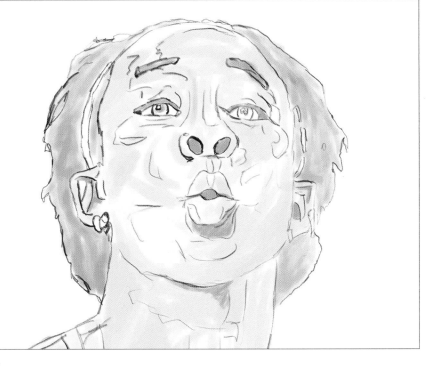

5 Using the no. 1 sable brush, add the Payne's gray wash to the eyebrows, upper eyelids, pupils, nostrils, ears, mouth, under the lower lip and under the chin. In a few basic steps we are starting to determine the shades and values in our painting.

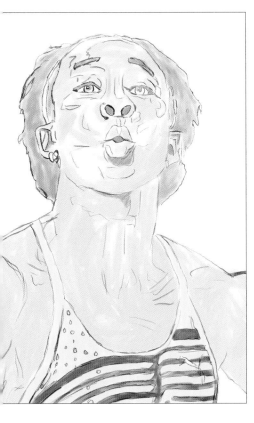

6 Change to the the no. 4 sable brush and add a light wash of green to the stripes on the vest.

7 Using the no. 4 sable brush, add some more burnt sienna to the flesh mix and apply this wash to the face. Start at the forehead and work around the side of the face and the nose.

8 Continue with this wash down the face, neck and upper chest. Once the paint is applied, blend it quickly with a dry no. 8 flat brush and continue to add the transparent layers to build up the warm colour. Blend using the contours of the face to add shape and volume to the figure.

9 Using the no. 4 sable brush, continue working this wash into the shoulders and arms. Remember to follow the muscle contours.

10 Using a mixture of black and burnt umber, add colour to the hair with the no. 4 sable brush.

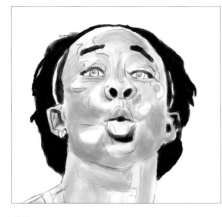

11 Use the no. 4 sable brush to add the dark colour to the other side of the hair but use only a burnt umber wash in the area on the left-hand side nearest the face. The burnt umber wash should then be applied to the eyebrows, upper eyelids, nose, mouth and ears.

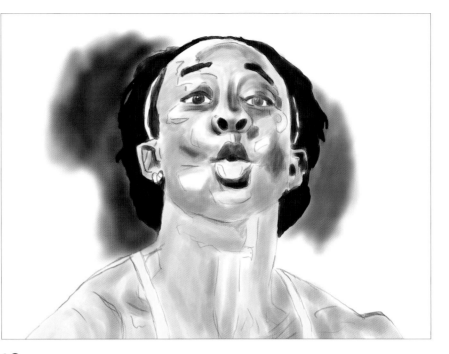

12 Use the no. 4 sable brush to add a light wash of Prussian blue to the background and also a wash of cadmium red mixed with a little Payne's gray and blend these in. Add a mixture of Payne's gray and burnt umber to the eyes, then add a mix of burnt sienna and a little burnt umber around the eyes, the bridge of the nose, the cheeks and upper lip. Using the no. 8 flat brush, blend these well into the surface.

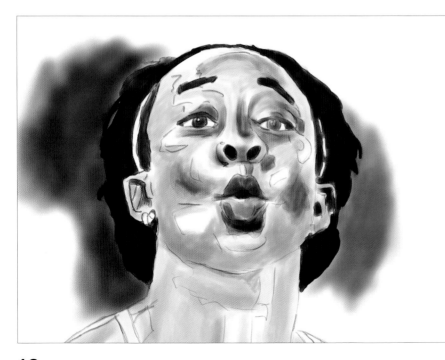

13 Add a little cadmium red mixed with burnt sienna to the end of the nose, the cheeks, the lips and around the eyes.

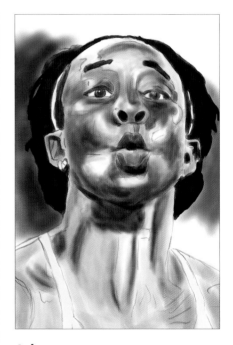

14 Using the no. 4 sable brush, continue building up the colours using these mixes and blending them into the surface with the no. 8 flat brush. Add burnt umber and Payne's gray to the shadows under the chin.

15 Blend a wash of yellow ochre across the face and neck to pull all the colours together. Continue using the no. 4 sable brush to add washes to the painting and use the no. 8 flat brush for blending.

16 Add a series of washes to the face: a warm mix of burnt umber with white and a little touch of red; and a dark mix of burnt umber mixed with alizarin crimson. Add another wash of the warm mix to the forehead and blend. Using the no. 1 sable brush, add detail to the eyes, eyebrows, ears, nose and mouth using burnt umber.

17 Continue the layering and blending down to the lower half of the face, using the warm mix on the cheeks and lips and the dark mix for shadows and shading.

18 Add a little orange created with a mix of red and yellow to the face and blend it in, giving an overall warm glow to the face.

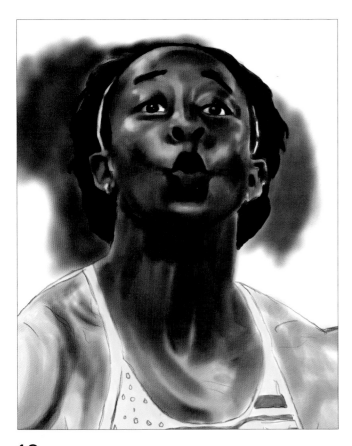

19 Continue the warm mix of burnt umber with white and a little touch of red down across the neck and the upper chest area, using several washes, blending each one in and allowing it to dry. Add the dark mix of burnt umber and alizarin crimson under the chin and for shading the muscles. When happy with the definition, add a wash of the orange mix particularly to the left-hand side of the neck. Add alizarin crimson to the lips and a little orange to the ear.

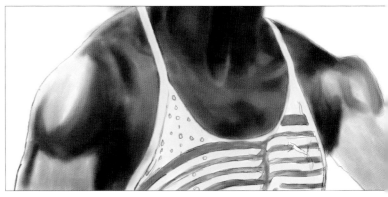

20 The arms are dealt with in the same way as the chest area. Use the warm and dark mixes from step 19 in layered washes and blend between the layers, taking great care to follow the muscle structure.

21 Here we see the effect of the continual washes and blending.

22 Using the no. 4 sable brush, build up the yellow and green in the vest. Add the little dark spots to the vest with a touch of the dark mix. Let the yellow dry before painting the green, but if they run into each other a little, don't worry, as you are not painting perfect detail.

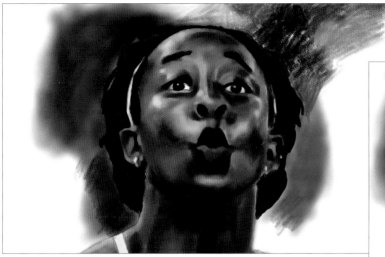

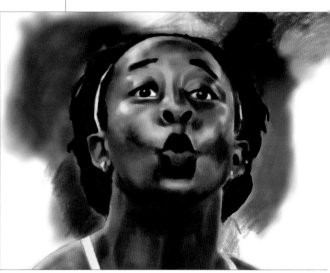

23 Add colour to the background using red, blue, dark blue, brown and white pastels. Draw on the surface in a hatch and cross hatch manner. Use a tortillon or a cotton rag to blend the pastel into the surface with a circular motion.

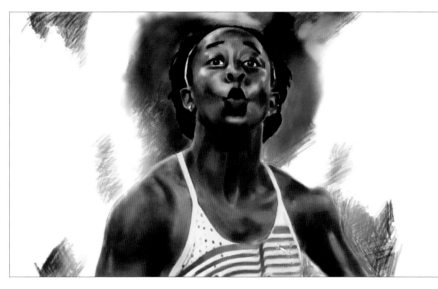

24 Continue adding colour to the background. Use small areas of pastel on different parts of the paper to help you balance the colours.

25 At the edges of the figure, use a tortillon to blend the pastels away from the figure.

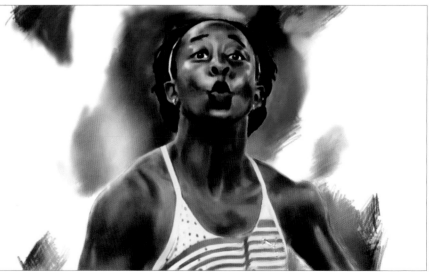

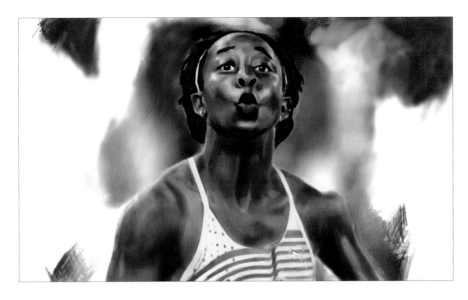

26 Continue adding to the background using pastels. Use colours that complement the colours used in the figure. The red of the background and the green of the vest are complementary colours, as are the blue of the background and the orange tones in the flesh.

27 When one side is complete, try to balance the other side with it by using similar colours.

28 Complete the background as shown. At this point we have an acceptable and complete painting. At this stage I sealed the background with several layers of acrylic fixative, allowing each to dry fully before adding further layers. This gave me a workable base to continue adding acrylic paint and coloured pencil to the background, as can be seen in my finished painting overleaf. You can, however, leave the painting at this stage if you prefer.

The finished painting

The vibrant pastel colours work really well with the built-up acrylic washes and have an interesting combination of textures. After step 28, I continued to work with the background and draw colours from the figure into the background. I feel that this style of working gives the artwork more drama and power.

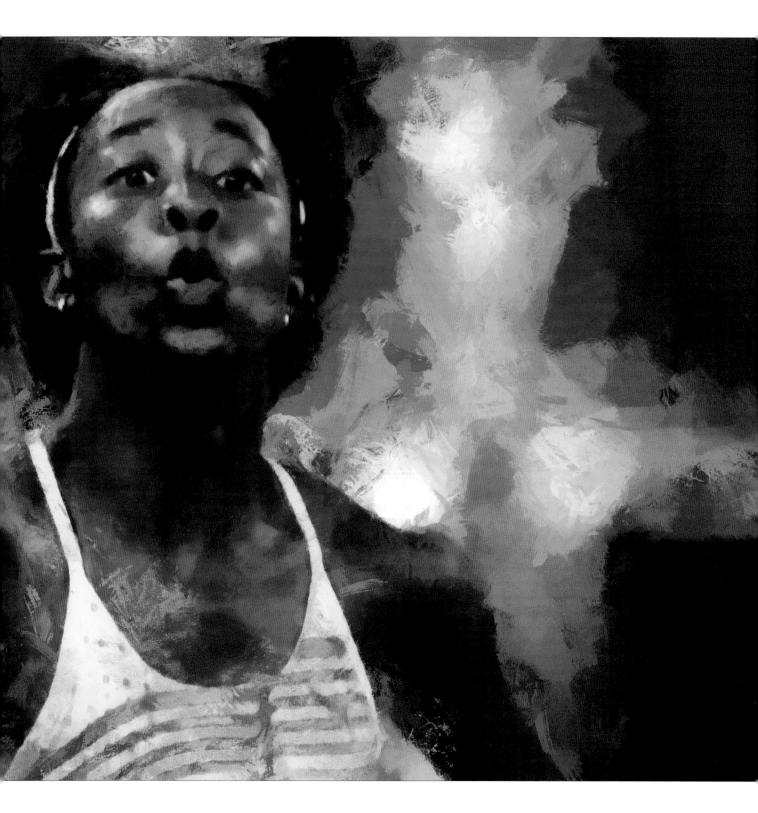

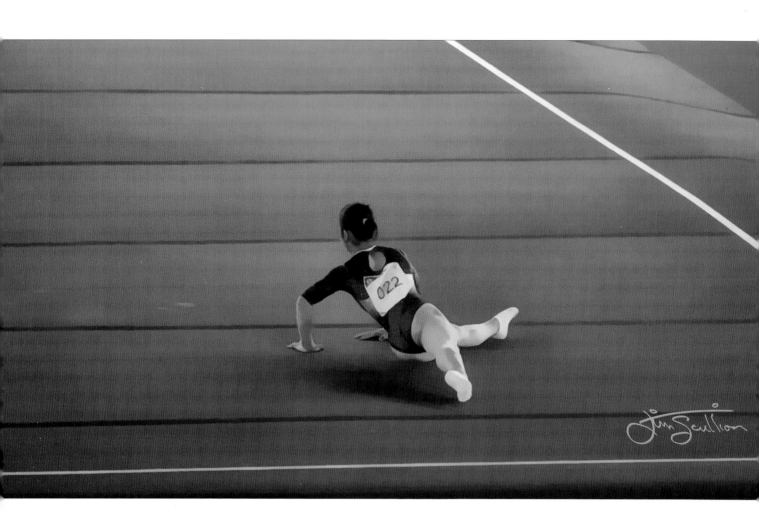

Floor Exercise

Not all paintings require the added dimension that I often add to my work. It is determined by the subject matter. In this painting of a gymnast created in acrylic, I have gone for simple washes and built up tones. I loved the geometric lines in this work which help give a sense of perspective. Gymnasts can be very young and slight and it was important for me to emphasise this by the small size of the figure, dwarfed by the vast competing area, which the lines indicate stretches far beyond the area of the canvas.
A simple approach for a complex sport.

Basketball

This painting is another simple approach to a fast-paced sport, painted in pastel and lacking any great detail. I have painted many basketball paintings over the years but none like this. Basketball is full of action; a team sport that is constantly in motion. By choosing this unusual angle and a point just before the action starts, we have a very calm painting but with just a hint of anticipation. I believe that if I chose to continue working on this painting, I would totally ruin the ambience.

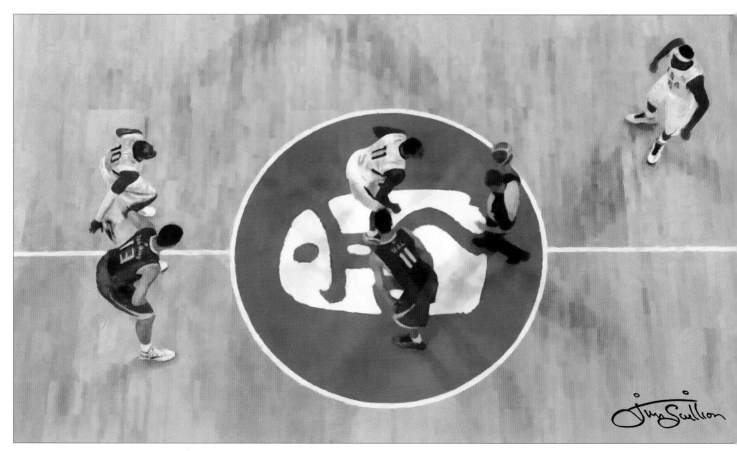

Index